THE FASHION YEARBOOK 2022

THE FASHION YEARBOOK 2022

BEST OF CAMPAIGNS EDITORIAL COVERS

Edited by Julia Zirpel
Art Direction by Fiona Hayes

Katja Sonnewend
Picture Editor

April von Stauffenberg
Contributing Editor

CALLWEY

CONTENTS

EDITOR'S LETTER

Fashion photography has always been more than just photographing beautiful people in beautiful clothes. Over the last century, photographers have both honored the work of great designers and pointed to broader social moods and shifts in politics.

But will fashion photography survive as we know it? At first came digitalization, then the pandemic. Magazines have been reorganized or discontinued, staff have been laid off, budgets have been cut. What does that mean for the industry? And for the images? How relevant are they today?

In our first issue of *The Fashion Yearbook*, in 2021, social responsibility was already omnipresent. Several fashion magazine covers focused on political issues: *Vogue* Italia's "No Photoshoot" January cover, which addressed the über-crisis of pollution and global warming. The September cover of British *Vogue* with activists Marcus Rashford and Adwoa Aboah and the "Diaries" cover of *LOVE* magazine were both inspired by the Black Lives Matter movement. The four September covers of Brazilian *Vogue* featured Amazon rainforest activists, and for the three December covers of Polish *Vogue*, supermodel Anja Rubik had herself photographed nude in protest against Poland's restrictive anti-abortion laws.

Social change also plays a leading role this year: in Carlijn Jacobs's "Fashion in the Fast Lane" for *Dazed* magazine, a new, very diverse generation sprints towards us with complete equality and verve. In "How Are You" for *Vogue* Portugal, the photographer explores the theme of loneliness during the pandemic. The editorial "The Cyclone" for Russian *Elle* addresses social inclusion. On the cover of *The Greatest* magazine, a new understanding of gender plays a major role – male, female, whatever. Do we even need these definitions anymore? The cover of Ukrainian *Vogue* is about body positivity, one of the subjects that is still a marginal

topic in 2021. And Thebe Magugu's campaign is about the self-made image of African identity and culture.

Again, this year, we reviewed hundreds of photo spreads and, together with our international jury of experts, made a selection of the most inspiring editorials, covers and campaigns for the book. It was incredibly difficult to make the final cut when there could have been so many more included here. But what caught our eye this year is the amazing energy, joie de vivre and positivity that fashion photography exudes now. It is the year of colors. They seem to shine our way to a lighter future. It is also the year of community. Many of the stories show several models. The message: We are not alone. It reflects our prevailing longing of this time. Look at the WSJ editorial and cover "Brighter Days Ahead" and you will understand what I mean.

What else? In photography, as in all fields, digitalization has received a huge push from the pandemic. In the Vogue Russia editorial "Code Red" the models are still real but everything else in these pictures was created on screen. In the Margiela campaign, we see mystical, alienated models floating in space in the surreal photographs. The Balenciaga Jersey campaign documents this trend by showing models wearing virtual reality glasses in an empty studio. The reality of our brave new world...

The question we asked ourselves before we started this book series: Does the world still need classic fashion photography? Is there nothing more important? Now, with the second edition of our book, the answer is a resounding: Yes, it needs it, absolutely! It's true, though, that to create fantastic worlds of images, you need a lot of time – and money; two resources that have become increasingly scarce. Even before the pandemic, the conditions for producing great fashion images were difficult. Budgets were slashed. A shoot that would have taken two weeks in the past was squeezed into two days, and photographers were no longer tasked with just producing an ad campaign or an editorial, but also with creating content for social media and behind-the-scenes stories. The pandemic has once again led to an acceleration of what was already on the horizon.

With the proliferation of different social media channels, our way of seeing has also changed. Social media is helpful in demanding recognition and denouncing inequalities, but in the public consciousness, a magazine still conveys credibility. And a cover is still considered one of the most important platforms on which a photo can make a statement. In the past, images were expected to be dramatic, elegant, elitist in their perfection, but now they signal inclusivity, authenticity, honesty and vulnerability. Imperfections are embraced. In 2021, diversity seems self-evident. How long have those in charge promised to put diverse ethnicities, bodies, age groups and genders on the catwalks and in photo spreads? For how long did nothing happen? And then suddenly, in 2021, tearing down patterns of thought: the awakening. Or at least the beginning thereof.

The budgets we work with today may be smaller than in the past, and the possibilities for extravagant set ups are limited, but creativity and beauty will prevail. "No one knows what tomorrow's world will look like," says former Vogue Italia editor-in-chief Emanuele Farneti. But we believe that, if something is exquisitely designed and printed, with really interesting ideas and good copy, you want to keep it and not trash it to be replaced next month. Because "fashion is a language with which you can address all kinds of things," as Farneti concludes.

I would like to thank our fantastic jury from all over the world and from different backgrounds: editors-in-chief, creative directors, stylists, models, fashion editors, art collectors and influencers. Our special thanks go to Anja Rubik, Annette Weber, Asanda Sizani, Ariel Foxman, Daniela Falcão, Donald Schneider, Jeff Li, Karen Boros, Masha Fedorova and Veronique Kolasa.

I would also like to thank Fiona Hayes for her inspired design; Katja Sonnewend for her never-ending patience when negotiating the image rights; April von Stauffenberg for making the texts shine. And, of course, Marcella Prior-Callwey for encouraging and supporting us to create this wonderful book.

Julia Zirpel, Editor of The Fashion Yearbook 2022

THE JURY

ANJA RUBIK

Polish-born supermodel, activist, philanthropist and creative Anja Rubik is one of the most successful models since the mid-2000s. She spent her childhood in Greece, Canada and South Africa, and, in 1999, after being scouted at a model competition, moved to Paris to make her debut at the Paris Fashion Shows. Three years later, Anja moved to New York, where she was booked by Burberry, Jil Sander and Stella McCartney. In 2005, Style.com named her the "Rising Star" of the fashion world. In 2011, the *International Business Times* called her the "most sought-after model in the world." She has been the face of campaigns for Saint Laurent, Chanel, Valentino, Gucci and Versace.

Over the years, Anja has gone beyond the fashion world to champion social and environmental issues. Since 2017, she has been a creative consultant and ambassador for Parley, an organization that promotes ocean awareness and sustainability. In 2017, she launched the #sexedPL campaign, which was followed by a book in September 2018. The project now has over 13 million views on various platforms and has sold more than 170,000 books.

ANNETTE WEBER

Germany's "Voice of Fashion" and "Editor-in-Chief of Hearts" are but a few of the many titles attributed to Annette Weber. She is also a highly successful influencer. After stints at *Elle* and *Bunte*, Weber was editor-in-chief of Germany's *InStyle* from 2007 to 2015 and played a key role in determining trends in the German fashion world. With her two passions – fashion and writing – she led the magazine to the top of the German magazine market at this time – in the process becoming quite an icon herself. Her idiosyncratic style, sense for fashion trends, and her humor are her trademarks.

After her time as editor-in-chief, she started her blog "glam-o-meter" and continued to build on her Instagram channels. "My projects are the exact continuation of my 'old' profession into the digital age. We curate fashion, show what we find beautiful. Only the result is not printed on paper, but online." Her trenchant columns can be read at *Bild*. In 2017, her book *My Style – Fashiongeheimnisse einer Chefredakteurin* was published. Her credo: "Women should make greater use of the power of fashion."

ARIEL FOXMAN

In 2009, Ariel Foxman was named one of the most powerful fashion editors in the world by *Forbes*. Foxman, who is best known as the editorial director and publisher of U.S.-based *InStyle*, became the brand's first male editor-in-chief at the age of 34 and held the title for eight years. Under his leadership, the magazine became the largest circulation fashion magazine in the United States with a readership of more than 15.8 million. Foxman oversaw *InStyle*'s U.S. edition, all 16 international editions and the magazine's online presence until 2016. Previously, he was a senior editor at Time Inc. and wrote for *The New York Times*, *Fortune*, *Wired*, *Details*, *Out* and *O at Home*. Foxman has interviewed personalities such as Michelle Obama, Julia Roberts and Kerry Washington. He has been a freelance writer and brand consultant since 2016.

In 2021, he took on a new role, having moved to Boston with his husband and child. He was named executive director of Boston Seaport, a development project that envisions real estate with cultural uses. His mission: to make Seaport a destination for fashion, culture, dining as well as technology and life sciences. Foxman is a contributing editor at *Vanity Fair* and writes for magazines such as *Architectural Digest* and *Maisonette*.

ASANDA SIZANI

Asanda Sizani is one of the most influential figures in South African media. She is an acclaimed editor, curator, style consultant and expert on African fashion. She started as the youngest fashion editor at *Drum*, became the first black fashion and beauty director at *Elle* South Africa and was editor-in-chief of South African *Glamour*. As a consultant, she has worked for brands such as Dove, Revlon and Unilever and executed campaigns for brands including Woolworths, H&M, Diesel and MaXhosa Africa. She founded Black Editors in 2020, a platform that advocates for black excellence in media: "The contribution made by Black women to the magazine industry as we know it today cannot be overlooked, and I have made it my mission to shine a light on them." Black Editors began as a series of interviews on Instagram and has quickly developed into an archive of experience and wisdom from editors and agents of change in the African media industry.

In 2021, Asanda was hired by Netflix as Creative Director on a project which honors a series of African pop-culture icons. An avid researcher, archivist and publishing editor with the media consultancy Legacy Creates, Asanda published a literary journal based on the life and legacy of Nokutela Mdima-Dube. As an extension to the print publication, she spearheaded an art series a music series and a short film titled *Amagama ka Nokutela* (*Nokutela's Words*) due for January 2022 release.

THE JURY

DANIELA FALCÃO

Daniela Falcão is best known as the longtime editor-in-chief of *Vogue* Brazil but worked as a political journalist for many years. She started her career at a local newspaper in Bahia, Salvador, and later at the *Folha de São Paulo* newspaper, where she worked as a reporter for eight years. After spending a year in New York on a project scholarship for young talent, she returned to work at São Paulo's other leading newspaper, *Jornal do Brasil*, eventually becoming editor of the weekly *Sunday* magazine. In 2003, Falcão shifted over to São Paulo-based pop culture and lifestyle magazines *TPM* and *TRIP* as editorial director. In 2005, Falcão became editor-in-chief of *Vogue* Brazil. Under her tenure, *Vogue* worked with some of the world's most celebrated photographers. As a passionate advocate of her homeland, and with an eye on the country's growing international profile, Falcão regularly featured Brazilian personalities on the covers.

In early 2016, she left her post at *Vogue* Brazil and was promoted to editorial director of Edições Globo Condé Nast where she remained until 2020. Her most recent project: the e-commerce platform Nordestesse, which empowers the talented entrepreneurs and creatives from the nine states of Northeast Brazil, her home region. The project is based on the pillars of fashion, design, visual arts, gastronomy and hospitality, highlighting products that preserve the knowledge of the local population.

DONALD SCHNEIDER

Swiss-born Donald Schneider started his career in New York, first as art director for the iconic magazine *East Village Eye*, then for *Fame* magazine, while also a member of the art department of the legendary nightclub Area. In 1991, he returned to Europe, where he was asked to redesign and art direct the rebellious "new journalism" magazine *Tempo*, and later German *Vogue*. Between 1993 and 2002, he was the creative director of *Vogue* Paris and *Vogue Hommes International*, collaborating closely with many of the most talented photographers, stylists, fashion designers, artists and upcoming talents.

In 2002, he founded his own studio for art direction and design in Paris. At Chloé, he created many iconic campaigns, for both Stella McCartney's and later Phoebe Philo's tenure. He also began working closely with H&M, art directing campaigns. In 2004, he initiated their first and game-changing global designer collaboration: "Karl Lagerfeld for H&M." Between 2010 and 2016, Schneider became Global Creative Director of H&M in Stockholm, responsible for all creative aspects of the H&M brand worldwide. He brought on board celebrities for special projects, such as Beyoncé, David Beckham, Jeff Koons and Sofia Coppola. He continues to be the creative responsible for the annual H&M designer collaborations, which have included Versace, Marni, Maison Martin Margiela, Isabel Marant, Moschino and Giambattista Valli. With Donald Schneider Studio, he works with clients such as Brioni, Cartier, Chloé, Hugo Boss, Highsnobiety and Wolford. He has received numerous awards, including LEAD Award's Creative Leader of the Year 2010.

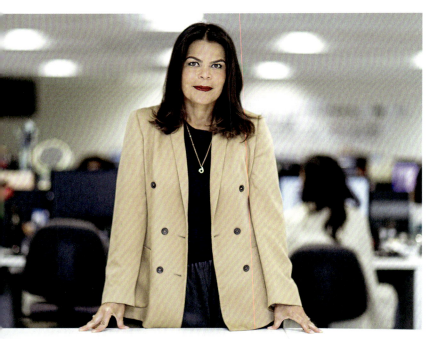

Daniela Falcão by João Viegas. Donald Schneider by Henrik Nielsen

FIONA HAYES

The Fashion Yearbook art director Fiona Hayes studied graphic design and art history in her native Dublin, Ireland, and started her career in media at the BBC in London. A fervent magazine lover, she has worked as art director of *Punch*, *Company*, *Eve*, British *House & Garden*, *GQ* India and the British and Russian editions of *Cosmopolitan*. In 2002, she founded independent photography magazine *DayFour*, publishing it continuously until 2012. She has had a lasting influence on the face of Condé Nast: as art director of Russian *Vogue* 1998–2000 and again 2010–2012. She also spent two and a half years in Munich with Condé Nast Germany. Between 2013 and 2019, Fiona oversaw all of the launches of Condé Nast International – 14 magazines, including seven editions of *Vogue*. She still consults as design director at large for *Vogue* Hong Kong.

Outside the publishing world, Fiona has been art director of contemporary art auction house Phillips de Pury in London and New York and consultant art director for Russian luxury retail group Mercury/TSUM. Current clients range from a multinational retail group to a boutique publishing organization.

She lectures on media at Leeds University, photography at Oxford Brookes University, and creative direction at Condé Nast College of Fashion & Design, London.

JEFF LI

Jeff Li is among China's "new class of image-makers spearheading changes to the Chinese beauty ideal and a comeback of a more traditional aesthetic in the country," according to *WWD* in 2019. The Shanghai-based fashion stylist is known for his straightforward and clean aesthetic. After graduating from Studio Bercot Paris, he quickly became part of the core Chinese fashion scene. In recent years China has moved away from the Western fashion establishment to create its own unique ecosystem to satisfy the growing demand for local celebrities and aesthetics. Having worked in the industry for a decade and witnessed firsthand changing tastes in China, Jeff sums up his experience: "China has this energy to embrace everything new. I feel like everyone is doing their own thing and experimenting with new ideas. I try to do mine."

In addition to working on editorials for the Chinese editions of *Vogue*, *Glass Magazine*, *GQ*, *InStyle*, *Numéro*, *Nylon*, *Wallpaper* and *T Magazine*, Jeff has worked on campaigns for Prada. He is the personal stylist of award-winning Chinese actress Zhou Xun and works on styling assignments for television.

THE JURY

JULIA ZIRPEL

Julia Zirpel is the editorial spearhead of *The Fashion Yearbook*. After more than 20 years as fashion director for various magazines in Germany, in 2017, Julia founded her own company: the wearness, an international e-tailer dedicated exclusively to sustainable fashion. Growing up in India, Nepal, the Netherlands and Germany, she studied fashion design in Berlin and New York. Her decision to focus on journalism led her to work as a stylist, editor and fashion director for magazines such as *Interview* Germany, *Myself* (Condé Nast Germany) and *Cosmopolitan* Germany.

Besides her online start-up, Julia Zirpel still works as a stylist, creative and content consultant for various clients and magazines. However, her passion has become the transformation to a more sustainable society. She studied Sustainable Business Strategies at the Harward Business School and participated in a program of the Ellen MacArthur Foundation on Circular Economy. She has established herself as a sustainability consultant for consumer brands and appears as a speaker on Female Empowerment, Sustainability and the Circular Economy. "The idea that bothers me so much is that many people think sustainability is all about doing without. When in fact it opens the doors to thousands of new possibilities. We can reinvent our world if we redesign every product, every process. There's a huge opportunity."

KAREN BOROS

Karen Boros is an art collector, fashion lover, style icon and, most recently, a runway model for Balenciaga. The psychologist and art historian is known as the female force behind Berlin's contemporary art collection and private museum, Sammlung Boros. With her husband Christian, she has established a reputation for treading ground that many other high-profile collectors would view as high-risk: from the experimental to the immaterial artworks that had yet to find firm-footing in the art market in the late 1990s. When the couple was looking for a place for their growing collection – which now includes more than 700 works – they happened upon a former WWII bunker in central Berlin. The space opened in 2008 and the first exhibition featured works by Olafur Eliasson, Monika Sosnowska, Sarah Lucas and many others. During its four-year run, it had over 120,000 visitors.

The couple is constantly expanding their collection, including works by Danh Vo, Elizabeth Peyton and Wolfgang Tillmans. During the pandemic, they organized an exhibition at Berlin's legendary techno club Berghain, showing more than 100 local artists. Since 2005, Karen has been the regional head of VIP relations in Germany for Art Basel.

Julia Zirpel by Wolfgang Müller. Karen Boros by Katja Sonnewend Masha Fedorova by Dima Shumov

VERONIQUE KOLASA

In 1982, Veronique Kolasa created Le Book. What started as a private resource for her friends – a collectable and well-designed reference, in limited edition, for the creative community in Paris – quickly became "the Bible of the image industry." Over the past 30 years, the annual print edition has been distributed to an international selection of elite creatives, who have defined the trends, strategy and image direction for the very best brands around the world.

Through collaborations with cultural icons ranging from Spike Lee to Diplo, and fashion legends Karl Lagerfeld, Azzedine Alaïa and Yves Saint Laurent, Le Book became the eagerly awaited Who's Who of contemporary talent, curating a selection of image-makers, art directors, stylists, models, production services, media, advertising agencies, fashion designers and PR companies. Through Le Book and the annual Connections events taking place in Paris, New York, London, Los Angeles, Berlin, Milan, Amsterdam and more, Kolasa presides over a network of more than 50,000 creatives around the world.

MASHA FEDOROVA

Masha Fedorova is best known as the former editor-in-chief of Russian *Vogue*. A graduate of the Stroganov Academy of Applied Arts and Industrial Design, she joined *GQ* Russia in 2001 as fashion editor and quickly rose to the position of fashion director. Masha then joined the founding team of *Glamour* Russia and worked there as fashion director for six years before taking on the role of editor-in-chief in 2010. During her eight years there, she earned a name for herself in the industry with her avant-garde editorial projects, addressing the issues of plus-size models and publishing a fashion shoot with Paralympic athletes. In 2018, she became editor-in-chief of Russian *Vogue* where she remained until 2021, after 20 dedicated years at Condé Nast.

EDITORIAL

hello
world

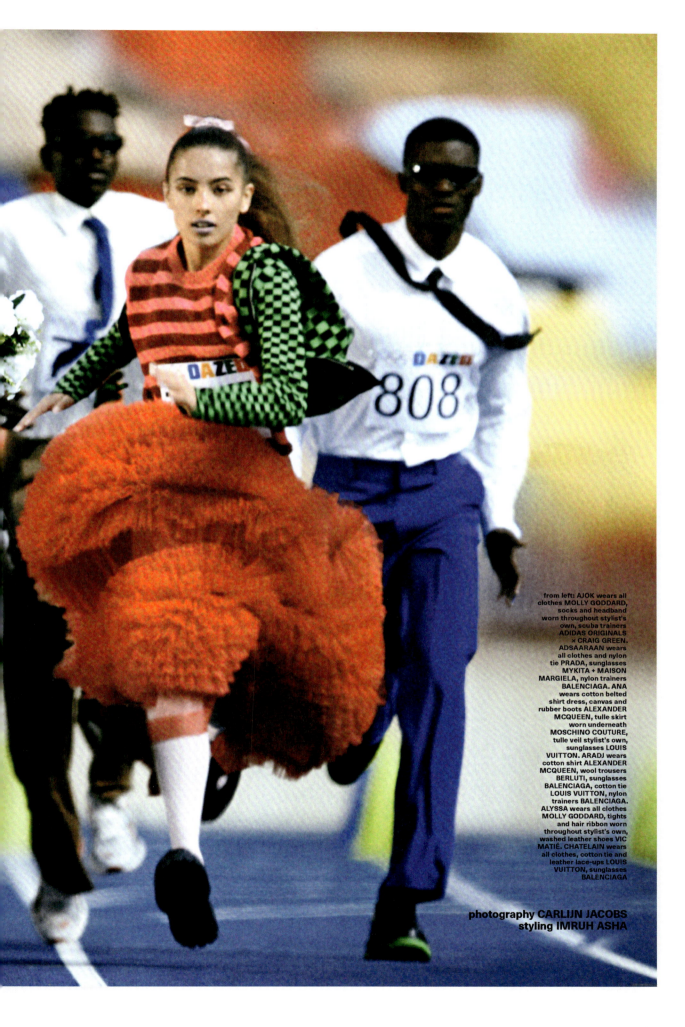

from left: AJOK wears all clothes MOLLY GODDARD, socks and headband worn throughout stylist's own, scuba trainers ADIDAS ORIGINALS × CRAIG GREEN. ADSAARAAN wears all clothes and nylon tie PRADA, sunglasses MYKITA + MAISON MARGIELA, nylon trainers BALENCIAGA. ANA wears cotton belted shirt dress, canvas and rubber boots ALEXANDER MCQUEEN, tulle skirt worn underneath MOSCHINO COUTURE, tulle veil stylist's own, sunglasses LOUIS VUITTON. ARADJ wears cotton shirt ALEXANDER MCQUEEN, wool trousers BERLUTI, sunglasses BALENCIAGA, cotton tie LOUIS VUITTON, nylon trainers BALENCIAGA. ALYSSA wears all clothes MOLLY GODDARD, tights and hair ribbon worn throughout stylist's own, washed leather shoes VIC MATIÉ. CHATELAIN wears all clothes, cotton tie and leather lace-ups LOUIS VUITTON, sunglasses BALENCIAGA

photography CARLIJN JACOBS
styling IMRUH ASHA

from left: ALYSSA wears sequin-fringed dress
ASHISH, nylon trainers BALENCIAGA.
AJOK wears embroidered crochet dress
BOTTEGA VENETA

top row, from left:
CLEA wears taffeta
dress MSGM, printed
canvas skirt and tulle
skirt worn underneath
MARNI, knitted hat
JOHN GALLIANO
ARCHIVES, earrings
worn throughout her
own. CHATELAIN
wears cotton dress
JW ANDERSON,
wool trousers LOUIS
VUITTON, leather
and rubber lace-ups
CAMPERLAB. bottom
row, from left: AJOK
wears all clothes
MOLLY GODDARD,
socks stylist's own,
scuba trainers ADIDAS
ORIGINALS × CRAIG
GREEN. ALYSSA wears
all clothes MOLLY
GODDARD, tights
stylist's own, washed
leather shoes VIC
MATIE. ANA wears all
clothes PRADA

top row, from left: AJOK wears knitted bra GCDS, printed toile skirt and tulle skirt worn underneath MARNI. ORLANN wears all clothes GUCCI. bottom row, from left: TYPHAINE wears embroidered sculpture dress SCHIAPARELLI HAUTE COUTURE, nylon trainers BALENCIAGA. MARALMAA wears all clothes and feathers headpiece JOHN GALLIANO ARCHIVES, nylon trainers BALENCIAGA

this page: TYPHAINE wears all clothes MIU MIU, embellished platform sandals SIMONE ROCHA. opposite page, from left: CLEA wears all clothes and satin collar SAINT LAURENT BY ANTHONY VACCARELLO. AJOK wears linen and wool cropped jacket and cotton trousers LOUIS VUITTON, cotton shirt and skirt DIOR, all custom made nun headpieces LAURA-LY

from left: ANA wears all clothes KIKO
KOSTADINOV, scuba trainers ADIDAS
ORIGINALS × CRAIG GREEN. MARALMAA
wears polyester blue vichy top, purple vichy
skirt and white tulle dress worn underneath
PHILOSOPHY DI LORENZO SERAFINI, cotton
red vichy dress SISTER JANE, knitted hat
JOHN GALLIANO ARCHIVES, strapped leather
ballerinas VIC MATIÉ

CHATELAIN
wears technical
polyester
sweatshirt
GUCCI,
Overthetop
frames OAKLEY

opposite page:
CHATELAIN
wears all clothes,
cotton tie and
leather lace-ups
LOUIS VUITTON,
sunglasses
BALENCIAGA

this page, clockwise from top: ANA, MARINA, ALYSSA, MAYA, AJOK, MARALMAA, CLEA wear printed Lycra bodysuits GUESS, tights stylist's own. opposite page, from left: CHATELAIN and ARADJI wear vintage JEAN-CHARLES DE CASTELBAJAC raincoats PASSAGE ARCHIVES, leather and rubber lace-ups CAMPERLAB. CHATELAIN wears wool trousers LOUIS VUITTON. ARADJI wears wool trousers BOTTER

hair OLIVIER SCHAWALDER at BRYANT ARTISTS using ORIBE, make-up HIROMI UEDA at ART + COMMERCE using CHANEL LES BEIGES SUMMER LIGHT and CHANEL HYDRA BEAUTY CAMELLIA GLOW CONCENTRATE, models CHATELAIN HYACINTHE at MARILYN, ALYSSA MORELLE at ELITE, CLEA BEURET at WOMEN, AJOK MADEL at OUI MANAGEMENT, MARALMAA ARIUNAA at NEW MADISON, ANA JORGE at NEXT, ADASAARAAN PIRA at THE CLAW, ARADJI SISSOKO at IMG, athletes ORLANN OMBISSA-DZANGUE at EMPAYA, TYPHAINE SOLDÉ, swimmers MARINA GENOVESE and MAYA LEROUX at THE CLAW, set design NARA LEE, photographic assistants CHLOÉ TRUONG, MANON TERNÊS, LUCAS MARIVAN, styling assistants ANITA SZYMCZAK, AROUA AMMARI, LAURA-LY TRAN, ANDRA-AMELIA BUHAI, make-up assistants MIKI MATSUNAGA, ARAKI SUGINO, hair assistants AUDE ANDREA, DAMIEN LACOUSSADE, choreographer ERIC CHRISTISON at PARENT, set design assistants LÉANA IPPOLITO, JADE RUEL-DÉROFF, production CHARLY FORIN at CINQ ÉTOILES, creative consultant CAMILA ABISAMBRA, production coordinator CHLOÉ LANNEAU, production assistants ARIANE COUDÉ DU FORESTO, MATTHIEU BERNER, SAMUEL BERNER, casting MISCHA NOTCUTT, casting assistant DOURANE FALL

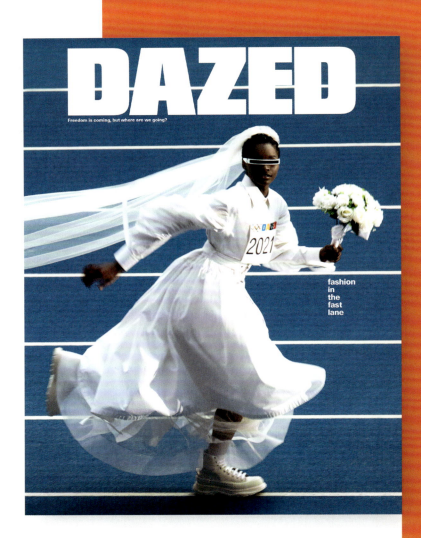

Fashion in the Fast Lane (Cover)
Hello World (Editorial)
Dazed Magazine, May 2021

Photography: **Carlijn Jacobs**
Styling: **Imruh Asha/Streeters**
Hair: **Olivier Schawalder**
Makeup: **Hiromi Ueda**
Set Design: **Nara Lee**
Choreographer: **Eric Christison**
Casting: **Mischa Notcutt**
Production: **Cinq Étoiles Productions**
Models: **Ajok Madel, Alyssa Morelle,
Ana Jorge, Chatelain Hyacinthe,
Maralmaa A**

The reality of the 2020 Olympics? Postponed by a year, no spectators, athletes quarantined...

And in *Dazed*? Probably the best dressed and happiest depiction of imaginary Olympic Games ever! The cover "Fashion in the Fast Lane" and the editorial "Hello World" are bursting with positive energy in the brightest colors. Instead of performance-enhancing spandex and ergonomic lycra, stylist Imruh Asha put his athletes in spectacular, voluminous frou-frou dresses and suits with sneakers for leaping over hurdles marked "COVID-19" into a more hopeful, and a certainly more va-va-voom future.

The images were shot by photographer Carlijn Jacobs in a Paris sports stadium. "In preparation for the shoot, I really dove into all the different Olympic sports – from running and gymnastics, to hurdles and javelin throwing. I watched a bunch of old sport documentaries and visited the stadium beforehand to get a feel for it. The mood is definitely very Flo-Jo, who was a big inspiration." Flo-Jo was the nickname of Florence Griffith Joyner, an American sprinter and Olympic champion. In the 1980s, however, the "first diva of the tartan track" was also known for her shocking style. Her trademarks were über-long, fake fingernails and garish, asymmetrical one-legged onesies, which she herself designed.

Carlijn picks up on this 80s feeling and shot most of the images with a long lens. The telephoto lens makes the models stand out sharply

against the completely blurred background – a technique that was used particularly often in the 80s.

Imruh also takes his cue from the 80s for this editorial. It was his first cover for *Dazed* magazine as the new fashion editor. "My initial message while coming up with the concept for the shoot was to show the world how youth are trying to run away from these hard times. We went very literal with it and had the models run around an Olympic court... I wanted them in the total opposite of sportswear, and to make what they wore a total contradiction to the situation they were in." It was choreographed by Eric Christison. "I wanted it to feel real and fun, and alive... Looking at the final photos, I love that everyone is on the same playing field: all winners in the end."

In this editorial, a diverse young generation crosses the finishing line. We hope they win.

Carlijn Jacobs

Native Dutch photographer and art director Carlijn Jacobs lives in London and Paris. When she was 25, her work was exhibited at Foam in Amsterdam, alongside that of Helmut Newton, in a show tracing the legacy of his distinctive, unconventional approach. *W Magazine* named her one of the eight young photographers to follow in 2020. With her evocative choices, she always tells a story that hasn't been told before. She says she likes to take things out of the comfort zone. She has worked for Bottega Veneta, Wolford, Mugler, Courrèges and Carven, and her work has also been published in *Vogue* Italia, *Vogue* France, American *Vogue*, *Purple Magazine*, *Pop Magazine*, *M Le magazine du Monde*, *L'Uomo Vogue* and *Another Magazine*.

Eric Christison

After an international career as a classical ballet dancer, including with the famed Ballett Zürich, Eric Christison took the plunge and combined his work with fashion and film production. With his Studio Christison, a choreographic and consulting company that spans dance, film and fashion, he advises designers and fashion houses, including Burberry, Cartier, Chanel, Gucci, Jacquemus, Louis Vuitton, Maison Margiela, Marni, Moncler, Nike, Tod's and Versace, and works with publications such as *Harper's Bazaar* China, *i-D*, *L'Officiel Hommes* Germany, *Numéro* France, *Self Service*, *Vogue Hommes* and *Vogue* Italia.

"I really love creating characters. It's about choosing and brainstorming about the type, the location, the style, the props, the culture, the atmosphere – everything! It's like making little movies."

Carlijn Jacobs

Eric Christison by Diana Luganski. Carlijn Jacobs by Nicola Delorme

HOW ARE YOU?

Em tempos de confinamentos e quarentenas, as interações humanas são raras.
Estamos isolados e, na maioria das vezes, a nossa paisagem é a cadeira, a mesa, o escritório.
Nestas páginas, Ferry Mohr cristaliza o pensamento e os humores do isolamento.
Fotografia de Ferry Mohr. Styling de Marcello Bona.

Blazer em lã, **Nanushka** na MyTheresa.com. Camisa em seda, **Gucci** na MyTheresa.com.
Calças em pele, **Tiger of Sweden**. Botas em pele, **Celine Homme by Hedi Slimane**.

Fato em lã e algodão, camisa e meias em algodão, sapatos em pele, tudo **Prada**.
Na página ao lado, colete em algodão, **T/Sehne**. Calças em algodão, **Emporio
Armani**. Sapatos em pele, **Balenciaga**. Meias em algodão, **Prada**.

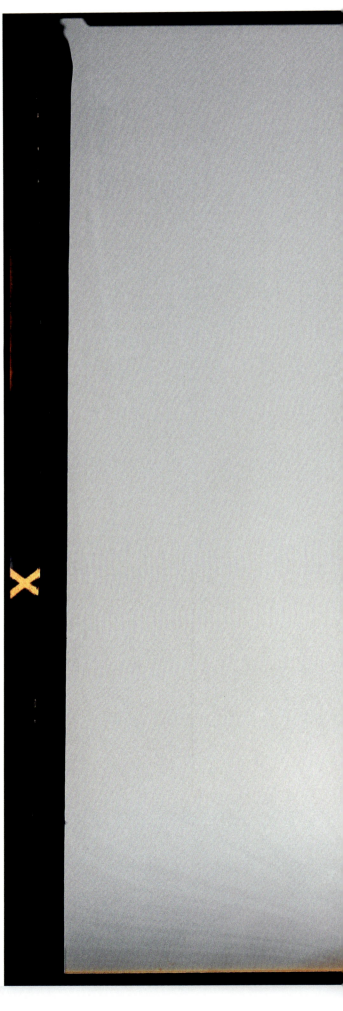

Casaco em pele, **Dior Men's Collection**.
Polo em algodão, **Lemaire** na MyTheresa.com.

Fato em fil e algodão, **Dries Van Noten**. Na página ao lado, casaco em fil e sapatos em pele, tudo **Balenciaga**. Camisa em algodão, **T/Sehne**. Meias em algodão, **Prada**.

Fato e camisa em
algodão e seda, tudo
Alexander McQueen.

Camisa em seda, **Gucci** na Mytheresa.com. Na página ao lado, fato e camisa em algodão e gravata em seda, tudo **Fendi**. Sapatos em pele, **Dior Men's Collection**. Meias em algodão, **Celine Homme by Hedi Slimane**.

MODELO: INGO @AGENCY TOMORROW IS ANOTHER DAY. **DIREÇÃO CRIATIVA E FOTOGRAFIA:** FERRY MOHR. **STYLING:** MARCELLO BONA @AGENCY NINA KLEIN. *GROOMING:* DENNIS BRANDT COM PRODUTOS DR BARBARA STURM E ORIBE @AGENCY BIGOUDI. **ASSISTENTE DE FOTOGRAFIA:** ENO DE WIT.

*Editorial
completo.*

How Are You?
GQ Portugal, March

Photography & Creative Direction: **Ferry Mohr/Schierke Artists**
Styling: **Marcello Bona/Nina Klein**
Grooming: **Dennis Brandt/Bigoudi**
Photography Assistant: **Eno de Wit**
Model: **Ingo Sliwinski/Tomorrow is Another Day**

It is March 2021: We are (still) in the midst of the coronavirus lockdown. We turn the pages to find an editorial spread. We see the tattooed bare back of a man in leather pants and the back of his head in an empty studio. The headline reads in utter sincerity: How are you? On the next pages the model turns his face to us. His character fills the otherwise empty studio. A chair, a table, a stool. What does the photographer Ferry Mohr want to tell us? And why is he inquiring about our well-being?

On his Instagram account, he writes in a caption: "...relationships with positive feelings are defined as resources of the human being... Depending on how much the value of social relation/exchange falls shorter than normal, the social isolation can cause significant mental illness. In times of lockdowns and quarantines, the inter-human exchange is rare. Most of the people feel isolated and – if home office is possible – the only thing they catch sight of is their chair, table and working medium... the question 'How are you?' may be trivial in a world without Covid. But these days even a small amount of attention will make life easier."

Mohr crystallizes the mood of isolation, holding up a mirror to his own feelings. Ingo Sliwinski's facial expressions underline the message. Forlorn, he looks into the camera: lost in this lonely white space. The story is a clear indicator of how much the image of man has changed. Men no longer have to be strong. They are allowed to show sadness and vulnerability. A face is perceived as beautiful – and this goes for the women, and all of us that find ourselves somewhere in-between – if it is authentic.

The trend is also reflected in the fashion of this spread. It is neither particularly masculine – nor (corona-appropriate) particularly comfortable. Instead we see pointed collar shirts, cowboy boots, suits without sleeves, a leather coat and a rose/pink degrade-dyed suit. Outfits that require confidence.

The model Ingo fits the role all too perfectly. He is vulnerable, he is authentic – and he looks simply fantastic in this fashion.

> ## "Masculinity means being authentic. Not letting yourself be pushed into a role you don't want to fill."
> *Ingo Sliwinski*

Ferry Mohr
Born in Düsseldorf, Ferry Mohr first studied apparel and textile marketing management and worked as an art director and producer at an agency before focusing on photography. Today he divides his time between photography and art direction and commutes between Bologna and Düsseldorf. The "motion blur" characterizes his works. His images are a mix of abstract and commercial photography, both in fashion and art. He has worked for clients including *Achtung Mode*, *GQ* Portugal, *L'Officiel* Malaysia, *Marie Claire* Mexico, and the labels Galvan London and Weyhe.

Ferry Mohr/Schierke Artists

Marcello Bona

Marcello Bona is an Italian fashion stylist born and raised in Germany. After his studies, he decided to dedicate his professional life to the fashion industry. "Throughout my life I understood fashion as a way to communicate and express myself in a very open way. I am passionate about creating stories that emphasize the young and modern as well as the history of fashion." Marcello works for various international fashion magazines such as *GQ* and *Achtung*.

Ingo Sliwinski

"I live and love fashion," says Ingo Sliwinski. The fashion buyer had been working at the Düsseldorf concept store Jades for 13 years when Eva Gödel, owner of the Cologne-based model agency Tomorrow is Another Day, strolled through the store in 2017. But it wasn't the fashion so much as Ingo that caught her eye. After a few persuasive words, he allowed her to take his photo – and, within a few hours, the first booking was made. The next day he had a fitting in Milan for the Ermenegildo Zegna runway show. Vetements followed suit. In the meantime, he was booked for campaigns by Balenciaga, Berluti, Lemaire, Matches Fashion, Salvatore Ferragamo, The Row, *Vogue* Italia and *Zeit Magazin*. His advantage: his age! And the character that comes in tow.

WHEELIE GREAT
"They are one amazing iconic triplet," says designer Jeremy Scott of models Shalom Harlow, Carolyn Murphy and Amber Valletta. From far left: Harlow in an Hermès bikini top, Dior shorts and sunglasses and Teva sandals; Murphy in a Jil Sander jacket, Calle Del Mar bodysuit, Falke socks and Saint Laurent by Anthony Vaccarello shoes; and Valletta in a Vivienne Westwood shirt, Dodo Bar Or bikini top, Dior shorts, Falke socks and Converse shoes.

THREE'S COMPANY

They burst on the scene together in the '90s. Today, longtime friends and models Shalom Harlow, Carolyn Murphy and Amber Valletta are still at the top of their game. What's the secret to their staying power?

PHOTOGRAPHY BY LACHLAN BAILEY
STYLING BY CLARE RICHARDSON

HAPPY DAYS
"This is lifelong good stuff," says Valletta of the trio's friendship.
From left: Stella McCartney sweater, Adidas shorts and Converse shoes;
Adidas jacket, Re/Done tank top, Balenciaga pants and 120% Lino
headscarf; Celine by Hedi Slimane jacket, Stüssy shirt, Miu Miu shorts,
Adidas socks and Converse shoes. Opposite, from far left: Re/Done
T-shirt and Louis Vuitton pants; Miu Miu jacket, bralette and shorts and
Adidas socks and shoes; Balenciaga jacket and Stella McCartney bikini top.

JUMP FOR JOY
Colorful choices
brighten things up.
From left: Cecilie
Bahnsen cardigan
and Priscavera
skirt; Heaven by
Marc Jacobs top and
Priscavera skirt;
Calle Del Mar top
and pants.

82

SLIDING HOME
"We all grew up together—we've been through so much and spent so much time together," says Murphy. From far left: No. 21 shirt, La Perla swimsuit, Adidas shorts, Falke socks and Converse shoes; No. 21 shirt and Hermès swimsuit; No. 21 hoodie and Les Girls Les Boys shorts.

SWING THEORY
Patchwork and patterns pair together well. From left: Celine by
Hedi Slimane sweater, Bode pants and Converse shoes (on all);
Murphy's own T-shirt and Dolce & Gabbana pants; Agolde jacket,
Fendi top and Chanel skirt. Opposite, from top: Etro shirt, Re/
Done T-shirt and vintage jeans; Celine by Hedi Slimane sweater
and Agolde jeans; Miu Miu jacket and Dodo Bar Or bodysuit.

WONDER WOMEN
Get ready for anything with swimwear or sweet pieces. From left: La Perla swimsuit, Teva
sandals and Zone3 Viper-Speed goggles; Gucci dress; Maryam Nassir Zadeh dress and COS
bikini bottom. Opposite, from left: Afterlife vintage T-shirt and Levi's x Valentino jeans;
Alexander McQueen dress; Re/Done T-shirt and Levi's x Valentino jeans. Previous spread,
on Murphy: Vintage T-shirt and shirt and Levi's x Valentino jeans; on Valletta: Model's
own vintage shirt, SIR. tank top, Re/Done shorts and Adidas socks; on Harlow: Mara Hoffman
bikini top, Dodo Bar Or swimsuit and Levi's x Valentino jeans.

TOWER RANGERS
"For us, we're just where we are at in our lives as women," says Harlow. From top: R13 hoodie, Falke socks and Converse shoes; Miu Miu dress and Teva sandals; Alaïa top and shorts, Falke socks and Converse shoes. Models, Carolyn Murphy and Shalom Harlow at IMG Models; Amber Valletta at The Society Management; hair, Shay Ashual; makeup, Mark Carrasquillo; set design, Heath Mattioli. For details see Sources, page 114.

MAY 2021

WSJ.

THE WALL STREET JOURNAL MAGAZINE

BRIGHTER
DAYS AHEAD

WITH CAROLYN MURPHY,
SHALOM HARLOW
AND AMBER VALLETTA

"And then the laughter, the joy came –
there's a safety there for us, we're just
where we are at in our lives as women."

Shalom Harlow

Brighter Days Ahead (Cover)
Three's Company (Editorial)
WSJ. The Wall Street Journal Magazine, May

Photography: **Lachlan Bailey**
Styling: **Clare Richardson**
Hair: **Shay Ashual**
Makeup: **Mark Carrasquillo**
Set Design: **Heath Mattioli**
Casting: **Piergiorgio Del Moro**
Models: **Carolyn Murphy, Shalom Harlow/IMG Models,**
Amber Valletta/The Society Management

When I first saw the cover and story of the WSJ, it hit exactly the feeling I'd been longing for all winter – and all year before: joie de vivre. The cover's tagline, "Brighter days ahead," gives readers hope. For sun and friends. Soap bubbles instead of those damn Corona aerosols. Our juror Annette Weber summed it up: "Super upbeat, positive, just in the Corona Spring, after the lockdown a wonderful, light and finally-moving-on cover and editorial."

We see three icons of the 90s surrounded by bubbles, as the low sun shines through green trees. They are longtime friends: Shalom Harlow, Carolyn Murphy and Amber Valletta. When they appeared on the scene, the trend had shifted from glamorous supermodels to girls who could wear both grunge and couture.

In January, they posted photos on Instagram of the three of them hanging out: "Girlfriends are like trees," wrote Valletta in her caption. "Strong, grounding, capable of handling great storms, regenerative, wise, and most of all they are oxygen." The team at WSJ had the idea of featuring the three longtime friends as cover stars in May, a lighthearted shoot in which the trio rides bikes, roller skates, plays in the sprinkler – an ode to the beautiful days ahead.

The background, however, is serious: The three women had gathered in Los Angeles to mourn Harlow's mother, as well as their friend, model Stella Tennant, who died suddenly in December, just days after she turned 50. Each of them posted photos from that day on Instagram, the three of them alone in the woods, no photographers, no makeup artists, no stylists. Just women hiking in jeans and sneakers. "We cried a lot," says Harlow. "And then the laughter, the joy came – there's a safety there and for us, we're just where we are at in our lives as women." Being together: "This is life-long good stuff," adds Valletta.

Photographer Lachlan Bailey says: "I was lucky enough to be asked to shoot these incredible women by WSJ with a completely open brief. My regular makeup artist and creative force Mark Carrasquillo sent me imagery of kids playing in nature."

Lachlan Bailey
Originally from Australia, Lachlan Bailey first studied Film and Media Studies, only to return to university to complete a degree in photography. In 2001, he assisted photographers in London before starting his own business in 2004.
Influenced by cinematography from a young age, his images have a very personal view of color, light and beauty. He brings a contemporary and natural beauty to his work that is alluring and often seductive.
Bailey has photographed for magazines such as *Vogue* France, *i-D*, *POP*, *Arena Homme+*, *Vogue* UK, *Man About Town*, *Dazed* and *Vogue* Japan. He also photographs advertising campaigns for major brands such as Chloé, Michael Kors, Ralph Lauren, Loro Piana, H&M, Emporio Armani, Calvin Klein, DKNY and Tommy Hilfiger.

Фото: **ЯН ЮГАЙ** / 3D-графика: **АРАМ ГЕВОРКЯН** / Стиль: **ОЛЬГА ДУНИНА**

Код красный

«ТВОРЧЕСТВО — ЭТО КОГДА ЧЕЛОВЕК МОЖЕТ ЧТО-ТО ЗАДУМАТЬ И ЗАТЕМ ВОПЛОТИТЬ», — ОТВЕЧАЕТ НА ГЛАВНЫЙ ВОПРОС НОМЕРА ФОТОГРАФ ЯН ЮГАЙ. ИСТОРИЯ, ЗАДУМАННАЯ И РЕАЛИЗОВАННАЯ ЯНОМ, РАССКАЗЫВАЕТ ОБ АДАМЕ И ЕВЕ ИЗ БУДУЩЕГО (ГДЕ, НАПРИМЕР, НЕ ТАК ОСТРО СТОЯТ ГЕНДЕРНЫЕ ВОПРОСЫ). ИСТОЧНИКАМИ ВДОХНОВЕНИЯ СТАЛИ СУПРЕМАТИЗМ, РАБОТЫ ДЖОРДЖО ДЕ КИРИКО И ПАУЛЯ КЛЕЕ, А ТАКЖЕ ЖИВОПИСЬ ЭПОХИ РЕНЕССАНСА. КРАСНЫЙ ЦВЕТ — ЗНАКОВЫЙ ДЛЯ РУССКОГО ИСКУССТВА — ЗДЕСЬ СТАНОВИТСЯ ЕЩЕ И ОТВЕТОМ НА ПРОИСХОДЯЩЕЕ В МИРЕ. УЖЕ НЕ БУДУЩЕГО, А НАСТОЯЩЕГО.

Платье
из тюля, **Fendi**;
трусы, **Alaïa**.

На странице слева.
Майка, **Alexander
McQueen**; брюки,
Fendi.

Нейлоновые пальто и платье, все **Prada**.

На странице справа, слева направо. Жакет из шерсти с полиэстером, **Saint Laurent by Anthony Vaccarello**. Водолазка, собственность стилиста.

Платье из атласа, расшитое кристаллами, **Miu Miu**; хлопковое боди, **Salvatore Ferragamo**.

На странице справа. Боди из хлопка с эластаном, **Alaïa**.

Code Red
Vogue Russia, March

Photography: **Yan Yugay**
3D Graphics: **Aram Gevorkyan**
Styling: **Olga Dunina**
Hair: **Nikolay Rish/
authenticbeautyconcept**
Hair Colorist: **Ekaterina Berenshtein**
Makeup: **Alena Moiseeva/Li-Ne**
Manicure: **Elena Chervyakova**
Casting: **Alina Kumantsova, Ilya Vershinin**
Photography Assistants: **Anton
Grebentsov, Pavel Radchenko/Bold**
Styling Assistants: **Anastasia Mitina,
Daria Baskova**
Hair Assistant: **Rudik Mkhitaryan**
Production: **Alina Kumantsova**
Production Assistants: **Anastasia
Pevunova, Ekaterina Prazdnikova**
Models: **Arseniy Daukshiz/NIK,
Tatiana Churbanova/Tumber**

In the *Vogue* Russia editorial, we see two models, a woman and a man. But there is nothing binary going on here. Masculinity has been played down: The man here is of the future, the future in which gender issues are a bygone relic of the past.

The most dominant protagonist, however, is the color red. We look to the headline and read: "The color red is an iconic color in Russian art. Here it is a response to what is going on in the world. Not in the future, but in our present." Ah-ha. We stand corrected: Our man is not of the future but of the now.

Red is a prominent color in Russian culture and history. The Russian word for red, *krasni*, is also used to describe the beautiful, good or honorable. The most important square in Moscow, Red Square, is one of the most famous examples of the red = beautiful connection. It is a common belief that Red Square was so named because of the color's association with communism and the Soviet Union. In fact, the Bolsheviks appropriated the color to symbolize the (honorable) blood of the workers.

The month *Vogue* Russia hit the newsstands, there was a newsworthy "red wave" sweeping across the country. In early February 2021, thousands of Russians (mostly females) could be seen on Instagram dressed in red. It started with Yulia Navalnya, the wife of Alexei Navalnyi, who wore a red sweater at her husband's court hearing. As a sign of support for them, the hashtag which translates into #DontBeSadEverythingWillBeFine was created, Navalnyi's now famous words to his wife after the verdict was announced. The hashtag has been used more than 21,000 times, mostly by women who post pictures of themselves in red dresses.

But something else catches the eye of the viewer: This is an artificial world.

The entire editorial was photographed in a studio. Instead of a real horse, a gym horse was used. In fact, the only real things in the pictures are the models. All else is 3D animation.

Producer Alina Kumantsova describes the process on Instagram: "First the sketch, then the pre-shoot, then the 3D rendering, another master shot, mixing, retouching, and only then could we see what we had!" The result: a play on very specific references, Suprematism and the works of Giorgio de Chirico and Paul Klee, the headline reveals. It reflects on the photographer's background in painting as well as current social and political affairs – shaped by our present-futuristic devices.

Yan Yugay

The Russian photographer was born in Beslan, a city in the North Caucasus region. Yan's mother is of Romanian descent, and his father is half Japanese, half Korean. In 1998, he studied painting at the Art Faculty of North Ossetian State University. "When I was about 30 years old, I bought a camera, but I still didn't take photos. Shortly after that, my mother got sick, and I quit my job to help her. My hometown is in the countryside, and there wasn't much to do. When I wasn't in the hospital, I photographed everything I saw around me – animals, people, life in general. When I went back to Moscow, I started working with photography." Yugay currently works for *Vogue*, *Esquire*, *GQ*, *Marie Claire*, *Elle* and *Harper's Bazaar*. He also works with painting, video and performance art.

"Creativity is when you are able to think of something and then bring it to life."

Yan Yugay

FLEETING MOMENTS

Glimpses of
new high jewellery
creations leave
lasting impressions

FAWAZ GRUOSI
white gold earrings
set with pear-cut
Zambian emeralds
and brilliant-cut
white diamonds

High Jewellery

BOTTEGA VENETA green shearling tie-waist coat; **LOUIS VUITTON** Bravery high jewellery collection yellow gold, platinum and white gold L'Aventure necklace set with emerald centre stone, LV Monogram flower-cut diamond, emeralds, brilliant-cut emeralds, custom-cut diamonds

Photography by
STEPHANIE PFAENDER

Fashion by
TIM TOBIAS ZIMMERMANN

JIL SANDER white knitted turtleneck jumper; **CARTIER** Sixième Sens par Cartier white gold necklace set with melon-cut chalcedonies, melon-cut emeralds, cabochon- and princess-cut sapphires, square-shaped emerald, onyx, turquoise and brilliant-cut diamonds

FENDI
black wool cropped
tailored jacket
with scarf collar;
COMMISSION
red wool A-line skirt;

CHAUMET
Torsade de Chaumet
white gold bracelet
set with square-cut,
brilliant-cut and
rose-cut diamonds

High Jewellery

MAISON RABIH KAYROUZ black silk satin tailored blazer and matching skirt; **STUDIO 163** black cashmere bralette;

VAN CLEEF & ARPELS white gold Sous les étoiles necklace with sapphires and diamonds

PETAR PETROV
black and gold printed
silk crepe dress;
JIL SANDER white leather
over-the-knee boots
with embellishments;

CARTIER
yellow gold Sixième
Sens par Cartier
earrings set with
cabochon-cut peridots,
melon-cut peridots,

rubellite beads and
brilliant-cut diamonds,
yellow gold Sixieme
Sens par Cartier ring
set with one cabochon-
cut peridot, melon-cut

peridots, rubellite
beads and brilliant-cut
diamonds

High Jewellery

CELINE black nylon
bralette with gold metal
Triomphe logo detailing;
MESSIKA rose gold
Dancing On Air earring
with diamond

Hair by SHAILA MORAN
Make Up by THIERRY DO
NASCIMENTO RADJOU
Make Up Assistant:
MARIE-CÉCILE BARRIOS
Photo assistant:
CLEMENS KLENK

Styling assistant:
REMY YOMBO
Casting by
BENEDIKT HETZ
Models: IRAN @
Woman 360 Paris
MOLIBO @ Rock Men

Fleeting Moments
The Week, November

Photography: **Stephanie Pfaender/Shotview Artists Managment**
Stylist: **Tim Tobias Zimmermann**
Hair: **Shaila Moran**
Makeup: **Thierry Do Nascimento Radjou**
Photography Assistant: **Clemens Klenk**
Styling Assistant: **Remy Yombo**
Makeup Assistant: **Marie-Céline Barrios**
Casting: **Benedikt Hetz**
Models: **Iran/Woman 360 Paris, Molibo Sow/Rock Men**

Fine jewelry pictures as we know them usually portray expensive jewelry on immaculately airbrushed models with perfect skin and hair. Unreachability here is a statement: Jewelry is for gods and goddesses. We mortals can only dream of such marble halls.

The title of this editorial, however, tells another story: "Fleeting Moments" (or so tells us this luxury supplement to the UK journal *The Week*). Nothing in marble here. That's how our lives are, after all; every moment is transient, erodible. Even if the subheading serves to contradict: "Glimpses of new high jewelry creations leave lasting impressions."

On the first double page, we see the most impressionable arctic blue eyes of the model boring into us. It is a pared-down image, minimal, excepting those large earrings set with emeralds and white diamonds and the model's slick bob strictly parted. Her name is Iran and her piercing eyes compete with the emeralds she has been employed to sell. Next to her we see the young (Gucci-fave) Mobilo in a bright green teddy coat. Around his neck he wears a diamond choker. On the next pages, we are accosted by unconventional styling and strong characters, along with strong cropping and unusual perspectives.

What's beautiful about these pictures is how imperfect the models are. Their imperfections are a foil to the gazillions of euros worth of diamonds they sport. The tiny blemishes on their skin are crystallized by the photographer's lens.

Responsible for these beautiful images is photographer Stephanie Pfaender. Her strength is to give each picture a documentary character. In her work, the models are never just projection screens, but always humans as well.

Stephanie Pfaender
Stephanie Pfaender is a fashion and fine art photographer living in Berlin and Paris, who grew up between a small town in Bavaria and France. She originally started as a graphic designer in Berlin after studying in Munich. During her time as a communication designer, photography became her passion – which continues to this day. Her visual language between high fashion editorial and domestic triviality situates her work in a space halfway between fine art and storytelling. Her portfolio thrives on a mix of spontaneous snapshots and high fashion shots. She is adept at incorporating landscape and cityscapes into her photography, giving each image a documentary feel. Selected clients include Swatch, MCM, Versace, Nike, Adidas, Mercedes-Benz, Levi's and Otto Linger. Her work has been published in magazines such as *Zeit Magazin*, *Interview* Germany, *SZ*, *Mixt(e) Magazine*, *Harper's Bazaar*, *Tatler* UK, *Indie* and *FAZ Quarterly*.

Tim Tobias Zimmermann
Swiss-born Tim Tobias Zimmermann is a stylist and creative consultant living in Berlin, London and his hometown Zurich. After completing his media business studies in Zurich and working for Zalando and the online portal Mytheresa, he joined *Glamour* Germany as an intern and eventually became its fashion editor. About four years ago, he decided to work as a freelance stylist. When styling, he likes to be inspired by cultural events and historical references. He spends his free time in museums and galleries. His clients include Aeyde, Andy Wolf Eyewear, Farfetch, *Document Journal*, *Vogue* and Condé Nast Germany.

Chemise en
polyuréthane et
veste en laine,
**COMME DES
GARÇONS
HOMME PLUS.**

Page de droite,
cerf-volant
en Nylon,
**MONCLER ×
CRAIG GREEN.**

MASCULIN PLURIEL.

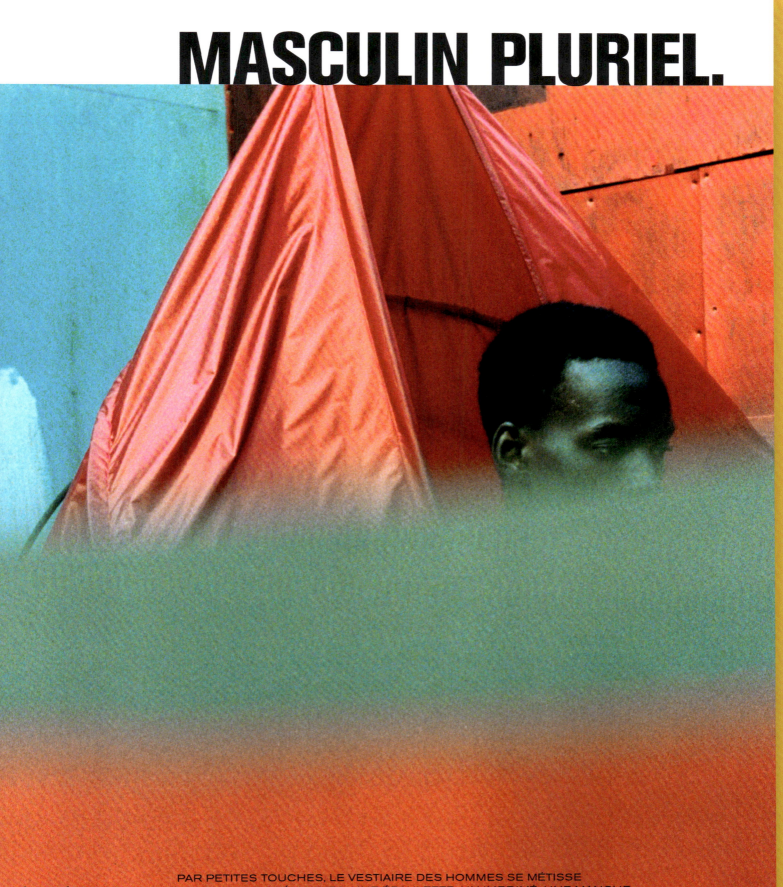

Photos Jack DAVISON
Stylisme Robbie SPENCER

PAR PETITES TOUCHES, LE VESTIAIRE DES HOMMES SE MÉTISSE
D'INFLUENCES FÉMININES. UNE ÉPAULETTE, UN IMPRIMÉ, UNE MANCHE,
UN PETIT VOLANT : TOUT EST AFFAIRE DE SENSIBILITÉ.

Page de gauche, chapeau en paille, **AK POUR VIVIENNE WESTWOOD.** Chemise en popeline de coton, **DIOR MEN.** Veste en laine, **VALENTINO.**

Costume en gabardine de laine, chemise en coton, **JW ANDERSON.**

En haut, veste
en tweed,
**ALEXANDER
MCQUEEN.**

Ci-contre, veste
en laine,
BALENCIAGA.
Blouson en
daim, **DOLCE
& GABBANA.**
Chemise en
popeline de soie,
**ALEXANDER
MCQUEEN.**

Page de droite,
chemise en
popeline de
coton et cravate
en Re-Nylon,
PRADA. Pull sans
manches et
pantalon en laine,
**BOTTEGA
VENETA.**

Ci-dessus, à gauche, blazer en laine et chemise en coton, **JW ANDERSON.** À droite, manteau en laine,
SAINT LAURENT PAR ANTHONY VACCARELLO. Tee-shirt à col roulé en coton, **MAXIMILIAN.**

Page de droite, en haut, blazer en laine et chemise en coton, **JW ANDERSON.** En bas, veste et pantalon
en laine, **LOUIS VUITTON.** Chemise en popeline de coton, **PRADA.**

Page de droite,
capuche en
pièces de métal
PACO RABANNE.
Blazer en laine,
VERSACE.

Ci-dessus, capeline en coton et Nylon imprimée, surchemise en coton imprimé, KENZO.
Manteau en laine, JIL SANDER.

Page de droite, chemisette en viscose imprimée, MSGM. Chemise en popeline
de coton, PRADA. Pantalon en laine, BERLUTI. Ceinture large en soie, GIVENCHY.

Ci-dessus, veste en laine, **EMPORIO ARMANI.** Chemise en popeline de coton, **HERMÈS.**
Pantalon en latex, **HARIKRISHNAN.**

Page de droite, polo en coton, **BOTTEGA VENETA.** Pull à col roulé en velours
et manches extra bouffantes en popeline de coton, **LOEWE.** Pantalon en laine, **BERLUTI.**
Ceinture élastiquée en coton, **DIOR.**

Page de gauche, débardeur en coton, **HUGO BOSS**. Chapeau en paille, **SAINT LAURENT PAR ANTHONY VACCARELLO**.
Ci-contre, veste et pantalon assortis, **LOUIS VUITTON**.

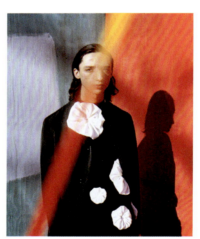

Page de gauche, pantalon en laine, **GIVENCHY**. Manchettes filets en coton et cristal, **BURBERRY**.

Ci-contre, manteau en coton technique Stretch, **PRADA**. Top et leggings en polyamide avec pompons en polyester, **MARCO RIBEIRO**.

En bas, veste de smoking en grain de poudre et satin, **DIOR MEN**. Chemise en coton et cravate en Re-Nylon, **PRADA**. Bandeau en perles, **SIMONE ROCHA**.

Ci-dessus, costume en polyester et satin, **SANDRA POULSON.** Chemise en coton
et cravate en Re-Nylon, **PRADA.** Chaussures en cuir, **ALEXANDER MCQUEEN.**

Page de droite, manteau en laine, **LOEWE.** Chemise en popeline de coton, **HERMÈS.**
Pantalon en laine, **ALEXANDER MCQUEEN.**

En haut, veste en laine, **EMPORIO ARMANI**.
Chemise en coton, **HERMÈS**.

Page de droite, chemise en coton et cravate en Ré-Nylon, **PRADA**.
Cape et jupe en laine, **SIMONE ROCHA**.

En haut, bikini en perles et sequins, **MATHIEU GOOSE**. Pantalon à taille élastiquée
et poches plaquées, en popeline de coton, **HERMÈS**.

Ci-contre, décor en lin plissé, **MARCO RIBEIRO**.

Page de droite, smoking en laine et soie, chemise en popeline de soie,
ALEXANDER MCQUEEN. Décor en lin plissé, **MARCO RIBEIRO**.

Page de gauche,
blazer en laine,
**EMPORIO
ARMANI.**

Ci-dessus,
trench-coat en
gabardine de
coton,
JW ANDERSON.

Top en coton
rayé, **MARNI.**
Chemise
en coton à
col officier,
DIOR MEN.
Pantalon en latex,
HARIKRISHNAN.
Derbys en cuir,
**EMPORIO
ARMANI.**

Page de droite,
blazer en laine,
VERSACE. Pull
à col roulé en
velours et
manches extra
bouffantes en
popeline de
coton, **LOEWE.**
Pantalon en laine,
BERLUTI. Derbys
en cuir, **EMPORIO
ARMANI.**

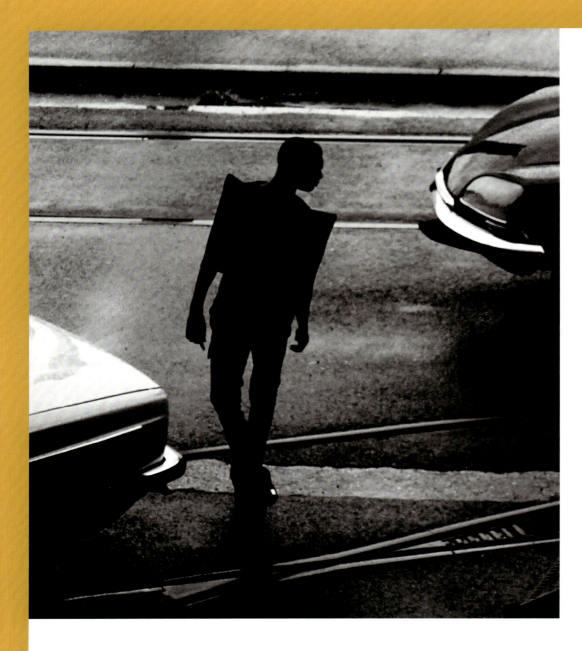

Ci-contre, veste épaulée et pantalon en satin, chaussures en cuir, **GIVENCHY.**

En bas, chasuble sans manches en satin ce soie matelassé et chemise en lin, **FENDI.**

Page de droite, costume en gabardine de laine, chemise en coton, **JW ANDERSON.**

Assistants du photographe : Maxwell Tomlinson, Tamibé Bourdanne, Louise Oates. — Assistants de la styliste : Met Kilinc, Isabella Pastor Damazio, Caitlin Moriarty, Kendall Blair. — Directeur de casting : Holly Cullen. — Coiffure : Mari Ohashi assistée de Hiroki Kojima. — Maquillage : Niamh Quinn assisté de Manabu Nobuoka. — Scénographie : Alice Kirkpatrick, assistée de George Hertzog Young. — Production : Mini Title. — Modèles : Bangali @models1. co.uk. / Patrick@xdirectn.agency. / Pharoah@supamodelmanagement.com. / Anya@tomorrowisanotherday.de / Pei Pei @milkmanagement.co.uk / AB @prm-agency.com / Max @premiermodelmanagement.com

Masculin Pluriel
M Le magazine du Monde, April

Photography: **Jack Davison**
Creative Direction: **Jean-Baptiste Talbourdet-Napoleone**
Styling: **Robbie Spencer**
Hair: **Mari Ohashi**
Makeup: **Niamh Quinn**
Set Design: **Alice Kirkpatrick**
Casting: **Holly Cullen**
Photography Assistants: **Maxwell Tomlinson, Tamibé Bourdanne, Louise Oates**
Styling Assistants: **Met Kilinc, Isabella Pastor Damazio, Caitlin Moriarty, Kandall Blair**
Hair Assistant: **Hiroki Kojima**
Makeup Assistant: **Manabu Nobuoka**
Set Design Assistant: **George Hertzog Young**
Production: **Mini Title**
Models: **Anya/Tomorrow Is Another Day, Bangali/Models 1, Patrick/XDirectn Agency, Pharoah/Supa Models Management, Peipei/Milk Model Management, AB/PRM Agency, Max/Premier Model Management**

Portraits in black-and-white next to dense images with strong colors. Photographer Jack Davison is known for this surrealistic pictorial aesthetic. His work is characterized by an intense use of light and shadow, a play on light and dark: he veils and reveals. Vacillating between clear, sharp details and dissolving mirages, with their deep shadows and tight cropping, his images have an unmistakably cinematic quality. He captures geometric cityscapes, carefully composed still lifes and – through the skillful use of reflections and long exposures – compellingly strange abstract compositions.

Davison has been greatly influenced by the Surrealist Man Ray, which is most evident in his black-and-white portraits. But in his colorful and carefully composed cityscapes, as seen in this editorial, one witnesses above all the influence of New York school photographer Saul Leiter.

Leiter is considered a pioneer of early color photography. As early as 1946, well before the proponents of the "New Color Photography" in the 1970s (such as William Eggleston and Stephen Shore), he was one of the first to employ the new medium, which was dismissed by fellow artists at that time. His sense of color and densely packed urban life represents a unique vision of the period, blending the genres of portraiture, still life, fashion, street and architectural photography. His subjects are shop windows, passers-by, cars. The reduction of the depth of field, the compensation or deliberate avoidance of light as well as the alienation caused by photographing through windows and by reflections merge into a veritable language of his very own.

And all of this we see reflected in the contemporary work of Jack Davison. The urban atmosphere captured in different layers, the blurred colored elements, the panes, mirrors, or shadows in the foreground. There's a story happening in every frame, *un grand affaire de sensibilité.*

Volker Conradus

Jack Davison

Jack Davison is a self-taught photographer who studied English Literature at Warwick University. At age 15, he began taking pictures with his family's Canon and sharing them on Flickr, a platform that taught him how to produce images. "I lived in the country, and my main access to images was the Internet. So I kept coming across other people's work and collecting things I saw that impressed me." Davison, who lives in London, makes images as a painter paints, creating photographs that excavate the surreal and sensual. After being named "One to Watch" by the *British Journal of Photography* in 2014, he received commissions from magazines such as the *New York Times Magazine*, *AnOther*, *Garage* and *FT Magazine*. He also works for *M Le Monde*, *Luncheon*, *Double*, British *Vogue*, *Purple* and *i-D*. Clients include Alexander McQueen's McQ, John Galliano, Hermès, Burberry, Craig Green and Moncler. His first solo exhibition, "Revisiting Pictures," was held at the Foam in Amsterdam in 2016.

Robbie Spencer

One of the most influential stylists of the last decade – included in the Business of Fashion's top 500 – Robbie Spencer's aesthetic is truly in tune with the Zeitgeist. He originally had a career in the art world in mind, wanting to be a curator, interior designer or set designer, and it is this artistic background that has greatly influenced his approach to styling. "I approach styling from the idea of creating an image or a space, not just from the clothes." He worked for *Dazed* magazine from 2004 and was appointed creative director in 2013. In 2019, he left the magazine and has since worked as a freelance stylist. Spencer has also styled numerous covers for magazines such as *AnOther*, *AnOther Man*, and *L'Uomo Vogue* and worked with talent such as Rihanna, Solange, Timothée Chalamet, Vivienne Westwood, Young Thug, Elle Fanning, Lana Del Rey, Willow Smith, Björk, Kendall Jenner, Iris Apfel, Lupita Nyong'o, Grimes and Mia Goth, among others. Robbie's clients include Simone Rocha, Craig Green, Y/Project, MSGM, Phillip Lim and Moncler. He has also worked with many other brands including Maison Margiela, MM6, Helmut Lang, Givenchy, Louis Vuitton, Gucci, Calvin Klein, Versus, Tod's, Hugo Boss, Armani, Ann Demeulemeester, Zara and H&M.

Глава 1. **Ураган**

Фото: **MARINA ADAM**
Стиль: **KSENIA PROSKURYAKOVA**

«Элли, растерянная, сидела на полу, схватившись руками за голову. Она чувствовала себя очень одинокой. Ветер гудел так, что оглушал ее. Ей казалось, что домик вот-вот упадет и разобьется. Но время шло, а домик все еще летел. Элли вскарабкалась на кровать и легла, прижав к себе Тотошку. Под гул ветра, плавно качавшего домик, Элли крепко заснула...»

170

ELLE.RU

Здесь и на странице
слева, на Полине: пла-
тье из шелка и льна,
ZIMMERMANN (ЦУМ); туфли
из кожи, GEOX; колгот-
ки, CALZEDONIA. Слева,
на Юлии (здесь и далее):
костюм из гобелена,
VENERA KAZAROVA; ботин-
ки из кожи, DR. MARTENS

Платье из хлопка, CECILIE
BAHNSEN (ЦУМ); шорты из
хлопка, ODOR; галоши из
полимера Croslite, CROCS;
носки, FALKE

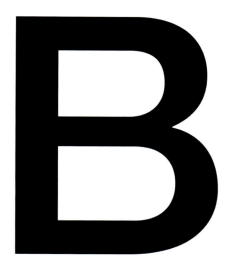

В

Волшебная героиня этой съемки — Элли — живет в своем замкнутом мире, который со стороны кажется странным и непонятным. Она изолирована — ураган унес девочку в неведомую страну, где у нее есть воображаемый друг — то ли сюрреалистичный Тотошка, то ли Жук. Но не стоит этого мира бояться или сторониться! Нужно образовываться, мыслить шире, развивать эмпатию и выступать за толерантность. Роль Элли блестяще исполнила очень особенная модель — Полина. О том, почему эта очаровательная девочка — другая, лучше всех рассказывает ее мама, Кристина.

«Полина — особенная девочка, и это сразу понимает любой человек, который с ней лично общается. Ей 15 лет, и диагнозов у нее очень много, перечислять придется долго. Самый первый, который ей поставили в четыре года, — умственная отсталость. Сначала в «легкой» форме, а потом — в «средней». Когда это случилось, мы, как родители, с этим диагнозом, конечно, были не согласны. Я думала, что врачи неправы, а мой ребенок — самый лучший! Ближе к школе стало понятно, что, к сожалению, ситуация не улучшается. На сегодняшний день Полина не умеет читать и считать. Она не знает, сколько будет 5 + 2. Она очень плохо пишет — коряво и по буквам, а говорит так, что ее не всегда понимают, поэтому мне часто приходится выступать в роли переводчика. Несмотря на то что долгие годы мы занимались с различными логопедами и другими специалистами, речь у нее быстрая и неразборчивая, и продвинуться в образовании не получилось. Целая история, как мы получали паспорт Полины. Мы три месяца каждый день тренировали с ней очень простую подпись. Я боялась, что она просто испортит документ, — например, распишется на всю страницу.

Особенностей у нее много, и они видны невооруженным глазом. Плюс у Полины стоит диагноз атипичный аутизм. Сейчас уже поняли, что аутизм бывает очень разный, и обычно говорят про «расстройство аутистического спектра». Стереотипный образ, возникающий в голове: человек, который ни с кем не хочет общаться и живет в своем мире. Но такое представление не всегда верно. Например, Полина постоянно пытается со всеми общаться, но с этим возникают сложности. Главная из них — она постоянно зависает на одних и тех же темах. Например, всем задает один и тот же вопрос: «Были ли вы на концерте группы «Мумий-Тролль»?» Мне кажется, что

в мире нет никого, кто любит эту группу сильнее Полины! Она знает все-все песни, у нас вся квартира завешана плакатами, а на первую зарплату модели Полина купила майку с названием группы. Если все люди ведут отсчет лет от Рождества Христова, то Полина — от дня рождения Ильи Лагутенко (1968 год) и его дочерей (2008-й и 2010-й). Знаете, как я за это время прокачала свои математические способности! Например, если кто-то при Полине рассказывает, что был в Турции в 2012 году, то она обязательно у меня спросит: «А сколько лет было Илье Лагутенко? А сколько лет было его дочкам?» И на Новый год с нами произошла самая удивительная вещь! Илья Лагутенко лично по вотсапу прислал Полине аудиосообщение с персональным поздравлением!

Даже в самых смелых мечтах я не могла подумать, что Полина может стать моделью. В последние годы я только и думала: что нам делать, когда она закончит школу? Может быть, ее на шоколадную фабрику устроить, конфеты заворачивать? Или уборщицей? При этом я понимала, что она никуда не пойдет, так как не может долго что-то делать и очень быстро устает. При этом Полина освоила инстаграм и теперь с помощью аудионабора «пишет» всем там без разбора всякую фигню — типа «были ли вы на концерте». Как-то раз, чисто случайно, она нашла там моего знакомого, музыканта, они начали переписываться. И в августе прошлого года он пригласил нас на свой концерт. Там мою дочку увидела девушка, которая работает моделью, и она предложила мне попробовать отдать Полину в модельный бизнес. А для начала — просто завести ей личный инстаграм. Я очень удивилась, но аккаунт создала (@polina.muha), выложив туда 10 красивых фотографий дочки. Через неделю, когда у нее было всего 36 подписчиков, мне написала Элеонора Дрыкина — гендиректор модельного агентства Genom Management (@genom_mgmt) — и предложила обсудить сотрудничество. Сначала я подумала, что меня, наверное, обманывают и будут просить деньги за съемки. Но на встречу в агентство все-таки решила сходить. Оказалось, что в Genom работают просто прекрасные люди, в которых я сразу влюбилась. Я рассказала им про все особенности Полины: про ее истерики, зацикленность на каких-то вещах, усталость и многое другое. Но они все-таки решили попробовать и сделали снэпы. Полина тогда ворвалась в студию, как ураган, начала тут же кричать «про концерт», бегала и ко всем приставала с расспросами. Мне сначала показалось, что все прошло ужасно, но через три дня агентство подписало с нами контракт. Я тогда чуть с дивана не упала! С тех пор у нас было много съемок. И на сегодняшний день я — мама настоящей модели.

У вас в ELLE публикация с Полиной вышла волшебная! И на самом деле меня не покидает ощущение, что последние полгода я живу в какой-то сказке». ∎

Пуловер из шерсти, JW ANDERSON (ЦУМ); пуловер из вискозы, THEORY (ЦУМ); брюки из хлопка, WOS

На Полине: платье из вискозы, FAITHFULL THE BRAND (ЦУМ); блуза из шелка, MAX MARA (BOSCOVESNA)

«Девочку нельзя трогать!

На Полине: топ из вискозы, MANGO; платье из хлопка, FABIANA FILIPPI

Это Фея!»

Платье из хлопка, LESYANEBO; блуза из эко-кожи с воротником из хлопка, MASTERPEACE; ботинки из кожи, DR. MARTENS; колготки, CALZEDONIA

На Полине: юбка из шерсти и полиэстера, J. KIM; туфли из кожи, GUCCI

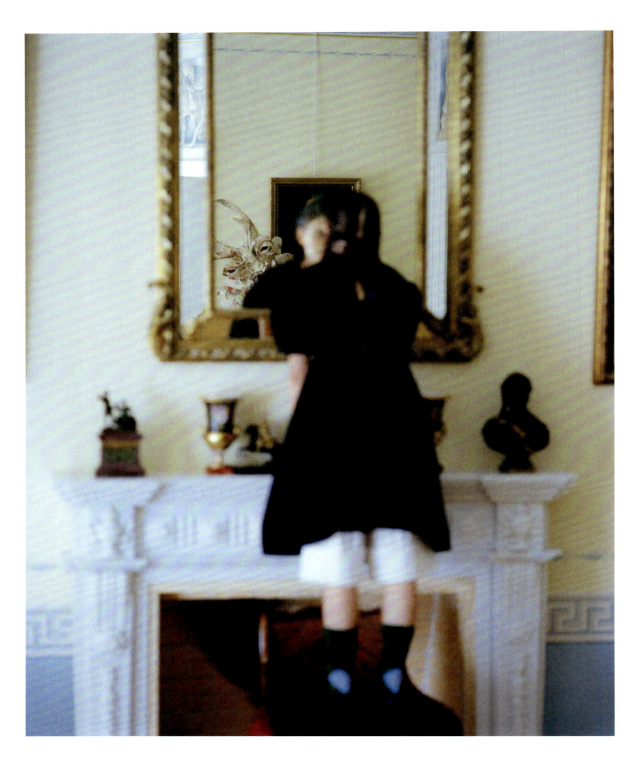

На Полине: платье из хлопка, CECILIE BAHNSEN (ЦУМ); шорты из хлопка, ODOR; галоши
из полимера Croslite, CROCS; носки, FALKE

На Полине: платье из хлоп-ка, CECILIE BAHNSEN (ЦУМ)

фото Marina Adam
стиль Ksenia Proskuryakova
модель Polina Muha
@Genom model
макияж Julia Rada
прическа Daria Sevastyanova
сет-дизайн Ksenia Kukushkina
ассистент сет-дизайнера
Julia Krivobokova
ассистент фотографа Andrey
Kharybdin @Bold Moscow,
Alexander Kulikov
ассистенты стилиста Elena
Zvereva, Valentina Antipina
продюсер Elena Serova

ELLE благодарит владельцев
усадьбы Степановское-
Волосово (Тверская область,
Зубцовский район) Сергея
и Маргариту Васильевых за
помощь в организации съемки.

The Cyclone
Elle Russia, March

Photography: **Marina Adam**
Styling: **Ksenia Proskuryakova**
Makeup: **Julia Rada**
Hair: **Darya Sevostyanova**
Set Design: **Ksenia Kukushkina**
Photography Assistants: **Andrey Kharybdin/Bold Moscow, Alexandr Kulikov**
Styling Assistants: **Elena Zvereva, Valentina Antipina**
Set Design Assistant: **Julia Krivobokova**
Production: **Elena Serova**
Model: **Polina Muha/Genom Management**
Acknowledgments: **Sergei & Margarita Vasilievs**

Here we find ourselves in a fairy tale that needs deciphering: The text accompanying the pictures leads us to *The Wonderful Wizard of Oz* and the moment when Dorothy (called Ellie in the Russian version) is swept away into a strange land by a cyclone. The magical heroine now lives in another world, incomprehensible to reality-bound fools like us. We too are trapped in our worlds; we unwittingly put up blockades against new perspectives. Shouldn't we all always be working to broaden our horizons more?

The role of Ellie is brilliantly played here by a different kind of model: Polina. Her mother Kristina expounds: "Polina is a very special girl, and that becomes clear to everyone immediately. At the age of four, she was diagnosed with an intellectual disability: atypical autism. The stereotypical image is that of a person who has difficulty communicating and lives in their own world. In the pictures, we see her with an imaginary friend taken from unusual perspectives and at times blurred. We see how her friend holds her captive. We see her view through 'new' eyes, drawn upon her hands. And we see her relegated to the corner. Is that where we (as a society) put her?"

On Instagram, photographer Marina Adam writes: "I'm truly proud of our recent fashion shoot for *Elle* Russia, where the main protagonist of our fairy tale is the young, incredibly beautiful Polina." Under another image she adds: "Instead of creating a gap we must educate ourselves and our children by creating social and educational inclusion... Embracing our differences is the key to equality."

But how did the shoot come about? "Even in my wildest dreams, I could not have imagined that Polina could become a model," her mother Kristina muses. By chance, they had met a model who suggested the profession to Polina. They started using Instagram – and a week later Eleonora Dryki from Genom Management, an inclusive model agency, got in touch. On the day of the shoot, Polina rushed into the studio like a cyclone, running around and asking questions. Three days later, the agency signed Polina.

Kristina adds, "Today I am the mother of a real model. I really feel like we've been living in a fairy tale for the last six months."

Marina Adam

Marina Adam started her career by studying performing arts in the renowned Russian Institute of Theatre Arts (GITIS) in Moscow where she received her first bachelor degree in acting in 2010. After several years, she realized she wanted to become an independent visual artist – and decided to take a step towards a new career. Marina took up fashion photography at the University of the Arts London (LCF) and graduated in 2018. Usually working with natural light and a medium format analog camera, Marina imbues her diverse subjects with a sense of mystery, romance, sensuality and power.

Ksenia Proskurya

Russian stylist Ksenia Proskurya studied economics before she decided to move into the fashion industry. After a five-year stint at *Vogue* Russia, first as an assistant, then as a junior fashion editor, she was headhunted by Ekaterina Mukhina, editor-in-chief of *Elle* Russia, for the position of senior fashion editor. Currently, she works as an independent stylist and creative director. "In my eyes, every individual is unique and beautiful, and I aim to show that beauty through my work. Social inclusion is a topic close to my heart, so I'm super happy to be able to raise awareness of it through this shooting."

"It's very important to talk about social inclusion. We all deserve a happy life and opportunities. I'm glad that though my photography I can talk about something really significant."

Marina Adam

Felipe Oliveira Baptista by Lutz Huelle

Felipe Oliveira Baptista was already a creative force to be reckoned with when he won the Grand Prix at the Hyères Festival in 2002. In the jury that year was Lutz Huelle, a fellow London-trained designer with European roots (Felipe is Portuguese, Lutz is German), known for his own, eponymous brand. Since then, the two have remained firm friends, and Oliveira Baptista has fulfilled the promise he displayed two decades ago. In 2019, he was named artistic director of Kenzo, a Parisian house whose heritage and focus are close to his own, displaying a profound respect for humanity and nature. Since arriving at Kenzo – coincidentally, the house's founder Kenzo Takada passed away shortly after his second show, having applauded the first – Felipe Oliveira Baptista has opted to work with recycled materials and to connect with key environmental causes, from fighting against the extinction of the tiger to the global plight of the bees. The latter was the inspiration for his Spring Summer 2021 collection, whose poetically digitalized flower prints and romantic colour palette also coincided with a timely focus on self-protection. It also seemed a natural choice to ask Lutz Huelle to talk to his old friend, joining Felipe Oliveira Baptista to discuss the state of today's world and the future of fashion – always with a positive outlook.

Photography **Osma Harvilahti** Styling **Imruh Asha**

so much about England as a country but just British culture, the music and fashion and clubs in London. Now when I think about this whole situation, how many people voted for Brexit in the UK, I almost feel betrayed, that maybe it wasn't the amazing a country I thought it was... There was such an openness and I never felt unwanted. Did you ever feel you were a foreigner in the UK.?

No, I didn't. I've felt a foreigner in other countries, but the British have a welcoming way of being that is very polite. Studying in Portugal was much more academic than in the UK, where there was an openness and willingness to break the rules. I was born a year after the Salazar's dictatorship ended in Portugal [in 1974], so I grew up in a country with a very young democracy. It felt very closed when I was growing up but luckily my dad was a pilot, so we got to travel a lot, which is what made me want to leave and go somewhere I could feel free.

When I arrived in London, the first year my hair went through all the different colours [laughs] and I was

en over everything...

Even regarding this pandemic, the outlook is p
Everything is. This past Christmas break, I took two we
I didn't leave Paris but I consciously didn't read nor wa
news. As creatives, if we have to exist and operate wit
situation that is very traumatizing, you do have to exi:e y
from reality and from the world.

That was the question I was asking myself: how do you
spired when there's nothing inspiring around you?
Before, we used to go into inside our brains and be i
by books and movies and so on. I find it interesting h
we can't go to the cinema, we can't travel... But human
to the worst situations. Even if it is an uncomfortable
really not as bad compared to what some other people
ing. So yes, it's about looking deep inwards and trying
ate surprises inside your own brain. I think I'm pushi
ple as well: I see some of the junior designers drapin

"People still need to wear clothes, so fashion is not going away... And it might sound naïve, but it can also help people dream and go through bad times."

FELIPE OLIVEIRA BAPTISTA

old t-shirts and it throws me back to how it used to be twenty years ago, so that is very interesting.

What I mean is what else are you going to do? It is difficult to work with less than what you were used to but it's such a good exercise.
Yeah, it is.

Like you say, it's about back to basics in a way, it's going back to when...
To when you had access to much less and you were not less creative for it.

To be honest with you, this past year I got so panicked at one point, because I had literally no idea what I was going to do, I had no idea where it was going to lead. The whole idea of actually dressing just seemed ridiculous. And then it came "un-blocked" when I was thinking about what you were wearing at home, lying in bed — you look at pyjamas, you design pyjamas. So that idea of going back to basics is so important — it might even be a good thing in the end.
This whole situation pushes you. I think designers need to

either offer something pragmatic or offer something *really* special and a bit outside the box. Or a combination of both. People still to need to wear clothes, so fashion is not going away... And it might sound naïve, but it can also help people dream and go through bad times.

It's not even naive to be honest, because when I work on a collection I ask myself: why do people wear clothes and why do people like fashion? In the end, it's about yourself, it's about feeling like yourself and making yourself feel better. When you feel good about yourself the world becomes a much easier place to deal with, and that's what fashion can do. It is a funny thing because in a way it's completely banal, but yet so important.
It's part of one's well-being and it's a means of self-expression. Fashion can help you to look at yourself in a new light. It's not as essential as eating, health and having a roof over your head, but it comes close.

There is something therapeutic about it.
And it gives you reassurance as well. I have clothes in my wardrobe that I have had for twenty years and, some of → 64

them, when I put them on I know that I'm in a safe place. They can give you a feeling of empowerment or security or quirkiness. You can feel different through clothes.

I agree: I think it's so important not to see fashion in a cynical way because it isn't cynical. It's something that is actually very important, and that will not lose its importance even if people buy less. I haven't bought that much but I have bought a few bits and pieces and I have been extremely happy doing it. [Laughs] Getting something and putting it on also means that your life is going to go on. There is going to be a tomorrow.

It's true when you said it's very important not be cynical. I am not talking about fashion as the "glitter" in an Instagram wonderland, I am talking about clothes that can make something inside you sparkle.

Do you feel like you have changed your way of working during the pandemic? The way you do research, for example?

Oh, completely. Going back to what we were saying earlier, there's no travelling, no going to museums, no going to the flea-markets... In a big brand, with many collections that need to be produced in year, research is vital. Now we have access to far fewer things. I never research much online. I love to go to old bookshops and flea-markets so I do feel a bit handicapped in that sense. But I have been looking at things that I did fifteen or twenty years ago, pick up on ideas that I find had a timeless quality to them and revisit them. I've only been at Kenzo for a year and a half, but there is so much history in the archives.

Kenzo has an incredibly deep history, so you must have a great deal to work with.

Yes, it's profound. Mr. Takada passed away three days after our second show. It was very strange, because I had had lunch with him only once, and then he came to the first show. I have been so deep inside the archives that I feel I know everything about him: it's as if I've lost someone I was very close to, even though I didn't get a chance to.

I remember him sitting at that first show clapping...

To know he was pleased was the best compliment. This brand carries his name, so I wanted him to be happy and proud. The beauty of Kenzo is how he did so many things out of instinct, love, and in a climate of joy.

That word that you just mentioned, instinct, I feel it's something that we never talk in fashion anymore.

And it's so important, it's vital.

The reason why all these designers became relevant is because everything they did was based on instinct. We have to make sure not to completely forgot this: if there is no sense of instinct in what you do as a designer, our work will eventually become irrelevant.

Those designers wanted to work in fashion because they had a passion for it. They knew what they loved, who they were, and they wanted to express their voices. Nowadays, this is something that tends to be squashed by our industry.

Because it scares people: how can you possibly quantify instinct? When I've presented work to people and they ask, why do you think it's right? Then the only thing you can say is..."I feel it."

Sometimes you can create something that people are not ready for. They want you to present something that is new, that ticks all the boxes all at once. But to be instinctive you need time: time to make mistakes and time to come back to things.

If people understand the value of instinct and emotion, then there are no limits to where a company can go.

People are always going to be touched by something that is unique and has a different or peculiar point of view.

If a company works around a vision and pushes it then the sky is the limit... But not everybody understands about vision.

Like instinct, vision cannot be translated or understood by everyone.

We say everything has changed but at the same time the basic values haven't changed at all. The basic values of how to design a collection, how to predict things, how to work for your clients, they all still exist.

I feel like all the cards are being shuffled and are going to be handed out again – there's a rim of light in this frightening situation. I am very sensitive to everything that is going around, but I am healthy, I am alive, and as long as there is life, there is hope. We need to try to do our best, one day at a time, since we don't really know when it's going to be over. We *don't know* and we have to learn to live with this uncertainty. → 73

"Fashion can help you to look at yourself in a new light. It's not as essential as eating, health and having a roof over your head, but it comes close."

FELIPE OLIVEIRA BAPTISTA

"Like instinct, vision cannot be translated or understood by everyone."

FELIPE OLIVEIRA BAPTISTA

The good thing about the future is that it's still unwritten so anything could happen. Especially when you look at fashion: new things always sprung up when an old system was obsolete. When you look at the Nineties, the reason why suddenly all these small brands from Belgium or England became big was because people were tired of the old guard. They wanted something new, that spoke about their new lives.
I was reading about the teenagers in France and about amount of vintage they are buying now. Maybe they realize that this fashion industry is producing too many clothes and they are going to start sewing again and patching things together, with more of a punk approach to things. There is a whole new generation of kids that holds the fashion industry partially accountable for everything that's going on with the planet and its resources.

For me, one worrying thing about the last ten years seeing young people dressing like their parents, doing the same things as their parents. You always expect new generations to rebel against the previous one, but I didn't see it happening. But maybe that is starting to change now...
I think it's changing. For a year now, my teenage son has been dressing in jeans and black t-shirts from my closet — he had reached my height, so we didn't buy him any new clothes. It was a reaction to having both his parents who work in fashion. A new generation of kids will be taking over soon — are they going to rebel furiously and party like there is no tomorrow?

I think it's healthy to ask yourself questions about what your parents have done — even if you have the nicest parents on earth. So they should, right? They should rebel.

There has been a lot of finger-pointing at these kids who have been having illegal parties but they also have to live, you know.

Our upstairs neighbours are students and they party every weekend. They make a lot of noise and I get really angry because they are so unconcerned about the situation.
Yeah, but imagine yourself being deprived of everything when you were that age.

Exactly — to be honest with you, I thought of calling the police, but then realized if I was their age I would probably do exactly the same thing. So in a way, you have to understand that this is not an easy generation nor an easy situation. But I think it will all be OK in the end.
Power to the kids! [Laughs]

Power to the kids — exactly. [Laughs]

All clothing and accessories KENZO

Make-up Satoko Watanabe at Artlist Paris
Hair Michał Bielecki at Bryant Artists
Casting Ikki Casting at Art Board
Videography Cle Gyimah
Set Design Nara Lee
Production Kitten Production
Photography Assistant Francois Briens
Styling Assistants Kenneth Okorley,
Aroua Ammari and Anita Szymczak
Set Design Assistant Léana Ippolito
Location/Studio Cyclo Paris
Retouching Sheriff

Models
Yous and Kaizen at Studio and Rayane at Rock Men Paris
Diarra at Elite Models and Maralmaa at New Madison
Jeanne and Valentin at Premium Models and Maeva Gianni Marshall

Kenzo by Felipe Oliveira Baptista
SSAW Magazine, April

Photography: **Osma Harvilahti**
Creative Director: **Chris Vidal Tenomaa**
Fashion Direction: **Tuomas Laitinen**
Styling: **Imruh Asha/Streeters**
Hair: **Michał Bielecki/Bryant Artists**
Makeup: **Satoko Watanabe/Artlist Paris**
Set Design: **Nara Lee**
Casting: **Ikki Casting/Art Board**
Production: **Kitten Production**
Retouching: **Sheriff**
Models: **Youssouf, Jeanne, Kaizen, Rayane, Valentin**

This editorial sets the stage for a long interview between two fashion designers: Lutz Huelle and Felipe Oliveira Baptista, the (now former) creative director of Kenzo.

Portuguese Felipe Oliveira Baptista was a creative force when he won the most important design prize for fashion, the Grand Prix at the Festival of Hyères, in 2002. On the jury in Hyères that year was the German Lutz Huelle, another London-trained designer, known for his spell as a designer at Maison Margiela and now for his own eponymous brand. Since Hyères, the two have remained friends. In the interview, they talk of politics, Brexit, the dangers of manipulation, the Corona crisis and the role of fashion in society. Baptista asks himself, "Why do people wear clothes and why do people like fashion? When you feel good about yourself the world becomes a much easier place to deal with, and that's what fashion can do. It is a funny thing because in a way it's completely banal, but yet so important."

In his second show for Kenzo, the SS 2021 collection, Baptista

worked with recycled materials to bring attention to environmental issues: from the looming crisis of the near-extinction of tigers to the global plight of bees. Using poetic, archival Kenzo floral prints, a romantic color palette and oversized veiled hats, he wields a new perspective on the theme of self-protection.

Deep into year two of the Corona pandemic, when we see Baptista's beekeeper-inspired hat, it's not bees that first come to mind, but clothing geared towards protecting us against those ever-present aerosols. The hats not only represent an extension of masks, but also social distancing by way of their breadth alone.

Finnish photographer Osma Harvilahti shot the images of this editorial, employing color, pattern and form as his prime protagonists. For him, photography is not only a means of observing and understanding the world, but also an instrument for isolating fragments of it.

The models are donned in diaphanous protective clothing – possibly as protection against a coming viral variation? One could imagine a post-Covid world in which such cocoons offered protection against a harmless swarm of Parisian bees: After all, the oldest hives in Paris have taken refuge on the roof of the Opéra for more than 100 years. The models are engaged in the most mundane activities, standing in line at the patisserie, dragging carry-on luggage over a crosswalk... (They travel, at least, and in high fashion.) Most shots are of several models in one picture, and yet it's not the feeling of a community or a band of friends but of individuals coexisting more than interacting. In their Kenzo garb, the models waft like flowers in a cityscape where nature has been deleted.

And yet this story is far from being a depressing portrait of our times. To the contrary, the photos have a very playful feel. In almost every picture are toys and children's props: a man "dressed" in balloons, a playground and a very glamorous slam-dunk at the basketball court.

In the end, the impression remains: In a world busy protecting itself from danger, it becomes mandatory to not lose sight of beauty or childlike joy. Or, in the words of Felipe Oliveira Baptista, "...it may sound naive, but (fashion) can also help people dream and get through bad times."

Osma Harvilahti
Born in Helsinki, Finland, Osma Harvilahti was surrounded by photography from a young age: "My mother, who is a photographer, was always taking pictures in the family," he explains. He graduated from the University of Helsinki with a degree in sociology and media. Today, he lives and works in Paris. Structured like a chain of ideas and visual narratives, his work is characterized by its vibrant color palettes and inventive compositions. "In my photographs, it's intentionally less about representation than about interpretation." His photographs can be seen in *The New York Times'* T Magazine, *M Le Monde*, *Vogue* France and *SSAW* Magazine. He works for Hermès, Kenzo and Lemaire.

"I tell stories, but the stories are plotless. All that matters is the surface of the image."
Osma Harvilahti

David Luraschi

COVERS

Balenciaga Couture
Hindsight
AnOther Magazine, September

Editor-in-Chief: **Susannah Frankel**
Photography: **Ola Rindal**
Creative Direction: **Marc Ascoli**
Styling: **Marie Chaix**
Hair: **Akemi Kishida/Blend Management**
Makeup: **Anthony Preel/Artlist**
Photography Assistant: **Léa Guintrand**
Styling Assistants: **Emmanuelle Ramos,**
Matthieu Bertorello
Hair Assistant: **Yulia Pantiukhina**
Makeup Assistant: **Azusa Kumakura**
Casting: **Julia Lange**
Production: **TheLink Management**
On Set Producer: **Gwenaelle Wieners**
Model: **Lisa Williamson/The Face**

"I feel I always look for beauty in places that are not conventionally understood so."

Demna Gvasalia

At first glance, this cover looks like classic 1960s/70s Gerhard Richter, a painting that resembles a blurred photograph. We see an elegant figure in an orange dress with a big hat through a frosted glass window. Or more precisely: a haute couture look… at a bus stop.

The look comes from the first couture collection by Demna Gvasalia, the creative director of Balenciaga. When Gvasalia joined the maison in 2015, it seemed a daring appointment at the time. His ready-to-wear designs from his own label Vetements put subversive twists on the "authentic" garment (the police rain slicker, the delivery man's t-shirt, my older brother's hoodie) placed on an otherworldly catwalk cast: androgynous, age-defying, goth, punk, anything but your typical runway model with a few typical runway models in-between just to keep us guessing what this upending scheme might be. He, of all people, has brought back haute couture to the brand.

"I felt it was my obligation." But still, there was "fear of not being enough. Fear of having to fill these very big shoes, left by 'the master of us all' …It's not just a legacy – it's Cristóbal Balenciaga's legacy."

Of course, Gvasalia took that legacy and made it his own, yoking the craftsmanship of couture into the silhouette of le street in a single garment. "For couture to be modern, it has to be a wardrobe," he explains. "We cannot get locked into the ballroom." And leave it to Gvasalia to create a visual strategy that disrupts traditional representational relations.

That's exactly what we see on the cover of *AnOther Magazine*. We see the model waiting to get there (somewhere, maybe just away from that "locked" ballroom that Demna mentions). She takes the bus because it's quicker than a taxi in all that Parisian traffic. Welcome to modernity.

Norwegian photographer Ola Rindal not only photographed the cover but also the entire fashion spread dedicated to Balenciaga in *AnOther Magazine*. Rindal is no stranger to the experimental – he likes to explore the ephemeral, the mysterious in his images. Like this cover image: a blurring that actually shows little yet generates a play between the visible and that invisible sensation: couture!

AnOther MAGAZINE

for ALL

AUTUMN/WINTER 2021 • LISA WILLIAMSON IS WEARING BALENCIAGA COUTURE PHOTOGRAPHED BY OLA RINDAL

Balenciaga Couture
Hindsight

Zoë Kravitz, Travis Scott, Demna Gvasalia, Miuccia Prada, Vivienne Westwood, Andreas Kronthaler, Alessandro Michele, Kim Jones, Patti Smith, Isamu Noguchi, Marina Abramović

Birth Of A Superstar
V Man, August

Editor-in-Chief: **Stephen Gan**
Photography: **Inez & Vinoodh**
Creative Direction: **Stephen Gan**
Stylist: **George Cortina**
Hair: **Lacy Redway**
Makeup: **Sil Bruinsma/The Wall Group**
Manicurist: **Megumi Yamamoto/
Susan Price NYC**
Lighting: **Jodokus Driessen/VLM Studio**
Photography Assistant: **Joe Hume**
Styling Assistants: **Moses Moreno,
Mary Reinehr Gigler**
Hair Assistant: **Sondrea Demry-Sanders**
Casting: **Greg Krelenstein**
Producion: **Tucker Birbilis, Eva Harte,
John Nadhazi/VLM Productions**
Location: **Pier59 Studios**
Recounting: **StereoHorse**
Entertainer: **Lil Nas X**
Acknowledgements: **Hodo Musa,
Kyle Hagler**

> "I want the takeaway to be that it's okay to be yourself, and I mean every aspect of your true self."
>
> *Lil Nas X*

Is this a throwback to the past on the cover of *V Man*? Jimi Hendrix? No, it's Lil Nas X, the hip-hop star (and first queer black man to top the country music charts).

In a more-is-more kinda look, the new American pop darling is draped in Missoni, Louis Vuitton, Saint Laurent and Gucci: luxury garments that a 20-year-old college drop-out, sleeping on his sister's sofa, could only dream of. Inside the magazine, he talks about his meteoric rise to the top of the industry, from that sofa upload of his first hit onto Soundcloud to his inspirations and struggles as a queer rapper.

Lil Nas X, who was born Montero Hill, debuted in 2019 with his viral crossover hit "Old Town Road" which catapulted him to mainstream stardom almost overnight. The now 22-year-old Georgia native masterfully fuses hip-hop and pop, ushering in a new era for the sub-genre we know now as hip-pop. Nas outed himself as gay while "Old Town Road" was at the top of the Billboard Hot 100, making him the only artist to do so while having a number one album – significant for any artist, but especially one from the country and hip-hop genres, both of which emphasize machismo and have "historically snubbed queer artists." Breaking through the glass ceiling of notoriously outdated notions and toxic machismo, against all odds, he has become a symbol of queer liberation.

"The album is me inviting people into the world of me... into the world of Montero. The project gave me the opportunity to bravely show different parts of myself. Parts that I may not have shown so openly previously. [From] being super aggressive at times on some songs [to] being cocky about where I feel that I'm going in life, and even being vulnerable with talking about relationships with my mom and family members."

Nas is undoubtedly living the life of a shooting star. On his own path, his boyish insouciance, he's charmed us all. Photographed by the giants of contemporary fashion photography Inez & Vinoodh (Inez van Lamsweerde and Vinoodh Matadin) and styled by the legendary George Cortina, the cover transforms Lil Nas X into a flower-power proud rock star.

VMAN

47

BIRTH OF
A SUPERSTAR
LIL NAS X

PHOTOGRAPHED BY INEZ AND VINOODH
STYLED BY GEORGE CORTINA
INTERVIEW BY KEVIN ABSTRACT
WEARING GUCCI

CHASE STOKES'
BIG BREAK

THE BOLDEST FALL
MENSWEAR SEASON EVER

HOW FINNEAS IS
REWIRING POP

Creativity
Vogue Portugal, March

Editor-in-Chief: **Sofia Lucas**
Art Direction: **José Santana**
Photography: **Karl Lam**
Styling: **Sean Kunjambu**
Makeup: **Evelyn Ho**
Manicure: **Jasmine Chan**
Styling Assistant: **Foxla Chiu**
Producer: **Katherine Ho**
Model: **Jason Mui**

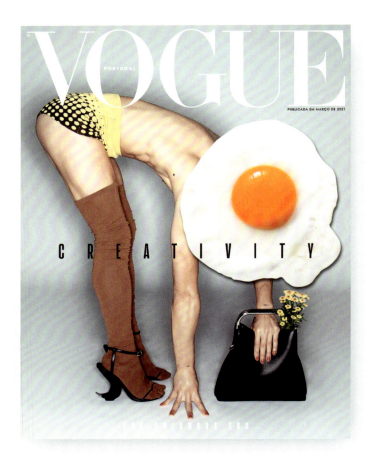

In March 2021, all 27 global *Vogue* issues joined forces under a common motto: "Creativity." It is the second round of united themes, following the "Hope" issue in September 2020.

What does creativity mean? Often, we think of art, design, music... But creativity is more than that. It is the gift to rethink, be it products, topics – basically everything. 2020 and 2021 may have been difficult years, but they were also blessed by a surprising surge of creativity. Historically, troubled times often lead to a renaissance: People are forced to dig up innovative solutions to new and preexisting challenges. In the midst of the Corona crisis, we are ready to question things that have always been so, with a sense of awakening spreading far beyond fashion to include politics, science, pop culture – just about anything under the sun.

We look at the covers of *Vogue* Portugal shot by the Hong Kong-based photographer Karl Lam and see a male model – or is it a woman? No matter. With glitter gloves, an "asparagus pendant," and a bag on his/her head. Or in high heels with over-the-knee stockings. In both covers, however, it is not the model who plays the leading role, but an egg! Boiled or sunny side up?

What's the point? Sure, it's the March issue. Is it supposed to be an Easter joke?

But stop. We read the subhead: The Columbus Egg.

On Instagram, Editor-in-Chief Sofia Lucas writes: "Creativity. What was born first: the egg or the cover?... A hymn to all the visionaries, to those who dared to take the first step and achieved the deeds that last until today, such as the famous 'Columbus' Egg.'"

Columbus' Egg makes reference to any simple solution to a seemingly unsolvable problem. The anecdote: Christopher Columbus, after his return from America, is reproached over dinner at Cardinal Mendoza's in 1493. Apparently, it was "easy" to discover the New World – anyone could have done it. In response, Columbus asks them to try making a boiled egg sit on the tabletop. Many attempts are made, but no one manages. Then Columbus is asked to try it himself. He hits the tip of his egg on the table so that it is slightly dented – and the egg remains standing. When the dinner guests protest that they could have done it, Columbus replies, "The difference, gentlemen, is that you could have done it, whereas I did!"

The Future
Kinfolk, May

Editor-in-Chief: **John Clifford Burns**
Photography: **Michael Oliver Love/
Hero Creative**
Styling: **Louw Kotze/Infidels Creative
Representation**
Makeup: **Michelle-Lee Collins/
Hero Creative**
Styling Assistant: **Thabisile Msibi**
Makeup Assistant: **Clanelle Burger**
Models: **Lebone Sebolai,
Yoyo Bonya/My Friend**

> "I am quite meticulous with my compositions and framing in a selfish way, to bring myself that sense of joy and balance – hopefully, it transcends to the viewer."
> *Michael Oliver Love*

A fresh new design for this anniversary issue of *Kinfolk*: In fact, it's been a decade since the very first issue went to press. On the cover, we see two models in balaclava catsuits, photographed in a light that casts a strong shadow from their static poses. They are surrounded by ominous black spheres, an abstract geography worthy of any good sci-fi flick, but what's the story here? That's easy, the title tells us: The Future.

It's a surprising cover, so out of step with what we've come to expect of the *Kinfolk* crowd. The decade of the generic "beige aesthetic" seems to be over.

Kinfolk is an American lifestyle magazine (nowadays with four international editions) that has become a style bible. Above all, it has significantly shaped the concept of slow living and a lifestyle characterized by mindfulness: picture elegantly spartan pages featuring young people doing earthy things. With an aesthetic that whispers "simple," often reduced to a few colors and natural materials, *Kinfolk* represents the combination of art and design nonpareil to any other magazine. Originally, the magazine was called *Kinfolk & Co.* to emphasize the importance of spending time with loved ones.

The cover was shot by Cape Town-based Michael Oliver Love. A promising photographer and artist, Michael Oliver Love creates images that are a burst of color, texture and ovoid forms that often stem directly from his own paintings. Faces emerge from holes, from shapes that suggest the influence of painter Ellsworth Kelly; shapes that inform his signature nonrepresentational compositions. Each would seem to indicate a yearning for simplicity, favoring primary colors such as blues, reds and yellows and experimentation with organic silhouettes.

Love wants people to enjoy his work simply for what it is: beautiful and necessary. He states: "I hope people get a sense of peace and balance from the frozen moments I try to capture, for the few seconds I can hold their attention in today's world." Ultimately, his goal is to give the viewer a decelerated moment that is, nonetheless, aesthetically easy on the eye. How appropriate for *Kinfolk* magazine.

KINFOLK

THE FUTURE
A curious guide to the unknown.

USD $18 CDN $21

VOGUE

ITALIA

new beginnings

S E T.
2 0 2 1
N. 8 5 2
€ 5,00

Hans Ulrich Obrist interviews artist Etel Adnan, 96, on colour, for the September cover.

H.U.O. Good morning, Etel. How are you? **E.A.** Good morning, Hans Ulrich. I'm well, thank you. How are things at the Serpentine? **H.U.O.** Great. We have just opened the new Serpentine Pavilion of Counterspace/Sumayya Vally. Etel, I'm so happy we can talk within this interview for Vogue Italia. You are in Erquy in Brittany and you're making a lot of work. I'd like you to talk about these new works. **E.A.** In my leporellos I combine differ- ent items and I do it according to my instinct. You know, objects talk to us,

artwork by Etel Adnan

we can discuss with them. Objects have a personality. They aren't just beautiful, they have an energy and they talk to us. They tell us "I am here", and they are. They look at us. Everything is alive, not only you, but whatever surrounds you is alive. It's like when you sit at your desk in the morning: everything moves and calls you.

H.U.O. Last time you told me that writing is drawing and drawing is writing. Recently you made a lot of drawings and colours have somehow disappeared. These new works are mostly black and white. Can you talk about that? **E.A.** I chose black and white after discovering I had some good Japanese ink. Black on white is extraordinarily powerful. Adding colour can make a drawing richer but it doesn't make it stronger. Black on white is very strong and doesn't need any colour. Also, when I'm not feeling well, colours get tiring because colour is another dimension you have to negotiate. And I don't have to. I just let black on white and I see it's really beautiful. I remember some highly geometric paintings by Mondrian. Those that are black and white are the most powerful. They're also very beautiful. **H.U.O.** But Mondrian brings us also back to colour. Red, yellow and blue... These are colours you also use a lot. **E.A.** Yes, red, blue and yellow are basic colours. These pure, strong colours are so beautiful you don't have the heart to mix them. That's why Mondrian used them without mixing them. They're as pure as the geometry of his forms. They have the same strength. When colour is pure you don't feel like altering it, you want to use it as it is. In Mondrian's case, there's a resemblance between the strength of his lines and the purity of his colours. There's harmony between them. Colours exist for me as entities in themselves, as *blue coat by Prada* metaphysical beings. Abstract art is the equivalent of poetic expression. You don't need to use words but colours and lines. I've never belonged to a language-oriented culture, but to an open form of expression.

hans ulrich obrist *with* *etel adnan*

VOGUE

ITALIA

SET.
2021
N. 852
€ 5,00

new
beginnings

massimo vitali

New Beginnings
Vogue Italia, September

Editor-in-Chief: **Emanuele Farneti**
Creative Director: **Ferdinando Verderi**
Casting: **Piergiorgio Del Moro,
Samuel Ellis Scheinman**

Previous spread, left to right
Artist: **Hans Ulrich Obrist interviewing
artist Etel Adnan**
Artist: **Massimo Vitali**
Models: **Dara Gueye/Elite,
Tina Diedhiou/Fifth Models**
Hair: **Alessandro Rebecchi/
The Green Apple Italia**
Makeup: **Miriam Langellotti/
The Green Apple Italia**

Opposite, top, left to right
Artist: **Precious Okoyomon**

Artist: **Jordan Wolfson**
Hair: **Hikaru Hirano/Frank Reps**
Makeup: **John McKay/Frank Reps**
Production: **Seduko Productions**
Authors: **Emma Nancy Cline, Ottessa
Moshfegh**

Opposite, bottom, left to right
Artist: **Torbjørn Rødland**
Hair & Makeup: **Lisa-Marie Powell/
Art Department**
Actor: **Diana Silvers**

Artist: **Thomas Ruff**

The September 2021 issue was the parting gift of Emanuele Farneti, outgoing editor-in-chief of *Vogue* Italia, whose tenure was strikingly vanguard. Farneti has never shied away from experimentation. In lieu of archetypal "fashion covers," for this issue, he collaborated with nine artists (and a curator): Anne Collier, Massimo Vitali, Michelangelo Pistoletto, Jordan Wolfson, Torbjørn Rødland, Tschabalala Self, Thomas Ruff, Precious Okoyomon, Etel Adnan and Hans Ulrich Obrist.

Some of Farneti's exceptional work in the recent past has included illustrated covers and a monochrome, all-white; there were issues dedicated to children's drawings, the cover "written" by Pulitzer Prize winner Michael Cunningham and the one in support of Venice affected by the floods. This September 2021 issue is a a cri de cœur for more creativity. For *Vogue*'s global theme "New Beginnings," Farneti and creative director Ferdinando Verderi decided to commission artworks that visually or metaphorically represent the sunrise, the rebirth of each day.

The variety of interpretation is here demonstrated by the artists. Hans Ulrich Obrist was asked to interview Etel Adnan, 96, a pioneer of women's rights worldwide, and the exchange of ideas between the two became a cover itself. Obrist, the artistic director of the Serpentine Galleries in London, is considered one of the most influential curators of contemporary art. For another cover, the *Vogue* team requested Massimo Vitali to shoot at dawn on the Tuscan beach of Rosignano Solvay, where he made his first monumental bleached-out shots of overcrowded beaches in the mid-90s. The artist Torbjørn Rødland shot American actor Diana Silvers. Photographed at dawn in Los Angeles, nature and romance collide to evoke a wide range of emotional and intellectual states.

Another cover is a collaboration between creatives: American artist Jordan Wolfson, best known for his animatronic artworks, asked the young literary stars Emma Nancy Cline and Ottessa Moshfegh to photograph themselves, before he went to work on the final design. Then there is a colorful cover by the Nigerian-American artist Precious Okoyomon. She created a work in which painting and poetry merge. Fragments of words, shapes, colors and fabrics tell a story of hope and love. And another great cover is designed by Thomas Ruff, one of the most important names in the recent history of photography. He uses a wide range of techniques in his work, combining analog and digital images, computer-generated imagery, archival photographs and manipulated images from newspapers, magazines and the Internet.

The Italian word for "rebirth" is Renaissance, after all. Hardly any other theme more aptly embodies this parting glance.

VOGUE
ITALIA

precious okoyomon

VOGUE
ITALIA

new beginnings

jordan wolfson with emma cline and ottessa moshfegh

VOGUE
ITALIA

S E T.
2021
N. 852
€ 5,00

new beginnings

torbjørn rødland

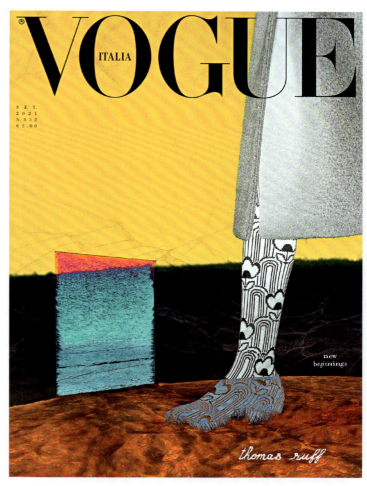

VOGUE
ITALIA

S E T.
2021
N. 852
€ 5,00

new beginnings

thomas ruff

Inside Out (Umgekrempelt)
Süddeutsche Zeitung Magazin, March

Editors-in-Chief: **Michael Ebert,**
Timm Klotzek
Photography: **Estelle Hanania/M.A.P**
Art Direction: **Birthe Steinbeck**
Styling: **Samira Fricke**
Hair: **Ciao Chenet/Bryant Artists**
Makeup: **Anthony Preel/Artlist Paris**
Photography Assistants: **Laurent**
Chouard, Daria Svertilova
Styling Assistant: **Pauline Barnhusen**
Casting Director: **Piotr Chamier**
Model: **Luna Kozaczka/Premium Models**

"What I look for: playing with codes related to dark worlds but more in a childish way, with a certain naivety. I am a very down-to-earth person, I like finding magic in common things."

Estelle Hanania

A radiant smile peeking out from under a fisherman's hat.

The hat is full of writing utensils: pencils, sharpeners, paper clips, neon hi-liters, post-its, a hodgepodge of delectable tools from a pre-digitized world. (It looks something like this on my niece's desk).

The title reads "Umgekrempelt." Not an easy word to translate, but loosely, perhaps, "inside out." The cover belongs to an editorial in the weekly *Süddeutsche Zeitung* magazine, a story about upcycling in fashion under the title "Nothing is Permanent." And what do we see? An earring-cum-felt-tip pen, a high-heel made from a badminton birdie, a bra made from a lemon squeezer and a vest made of oven mitts: objects fashioned by New York upcycling artist Nicole McLaughlin.

Many of her pieces incorporate childlike elements: Lego, toy cars, gummy bears. "The childhood sense of wonder just naturally comes out in my studio; it's very much a place of tinkering and playing around until things work… I think a lot of the time when we become adults, we lose fun and playfulness. I try to keep that."

But her objects have a serious background: "When I was 22, shortly after my graphic design studies, I got a job at Reebok. That was when I was first confronted with the huge amounts of material that go into fashion. My desk was permanently overflowing with shoe samples and fabric swatches that were simply burned a little later. I started combining this trash in my spare time with other things I had lying around at home or found in thrift stores – and made something new out of it." She continues: "It showed me that nothing is permanent. Every single item has the potential to be something completely different, you just have to look closely." Her goal is to combine sustainability with fun and functionality. Design should be more than just drawing and creating, but an understanding of the how/why/what we can do to change the future.

The images were photographed by Estelle Hanania. She brings this apparent contradiction between serious topics and lightness to the forefront in her images: "What I'm looking for in a subject is this idea of apparent contradiction. I love when the subject isn't what it looks like."

Nummer 10 | 12. März 2021

Süddeutsche Zeitung Magazin

Umgekrempelt

Ein Frauenheft

Wieso sollten die Dinge bleiben, wie sie sind?

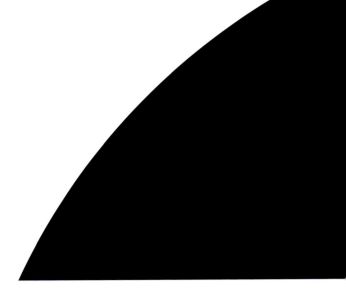

Chic Is Back
GQ Style Germany, Spring

Fashion Director: **Tobias Frericks**
Photography: **Julia Noni/Trunk Archive**
Styling: **Tobias Frericks**
Hair: **Gregor Makris**
Photography Assistant: **Hudson Hayden**
Styling Assistant: **Sharina Lichtl**
Casting: **Stephan Dimu**
Production: **Walandi Apoussidis/
WA GmbH**
Model: **Ottawa Kwami/Nest Model
Management**

"Chic is Back": and so heralds German *GQ Style*. It is a cover with incredible power and presence: bold colors, bold layout and typography and the bold attitude of Ghanaian model Ottawa Kwami. Tobias Frericks (now Head of Editorial Content at *GQ* Germany) says: "This *GQ Style* is an issue about attitude, and doing so with joy: about summer, life and everything that matters. Also, fashion."

The cover comes from a fashion spread in the magazine titled "New Big Fits," about modern tailoring, color, oversize cuts and the 90s vibe. In fact, the cover, with Ottawa wearing Louis Vuitton, reminds us of an earlier era, and the icon of all icons of the 80s, Grace Jones. The cover seems like a visual marriage of two of Grace's albums: the blue and red of *Island Life* (1985) and the portrait-style (and that signature flat-top hair) of *Nightclubbing* (1981).

Julia Noni, the photographer, always has her finger on the pulse: In her photography, she has consistently paid attention to a diverse cast of characters and has developed a distinctive style. Her work is characterized by a perfect composition of rich and strong contrasts; her striking point of view, graphic sensibility and electric color palette are what thrust her images into the ultra-contemporary realm. The composition of this cover is so perfect, it almost looks like a painted still-life – if a still-life could boogie, that is. You can tell that Julia has studied illustration, film and performance in addition to photography.

With her signature style, she is one of the more significant trendsetters when it comes to color in 2021 fashion photography. And color is one of the very big themes this year. Instead of "Chic is Back," the cover line could have also been "Color is Back." Indeed, we long for a life that is more intense, dramatic – charged with color.

> "In the beginning, there is always the question of what story we want to tell and how I can photograph that authentically. The fashion is then the fantasy in it."
>
> *Julia Noni*

GQStyle

MIT

Virgil
Abloh

Raf
Simons

Miuccia
Prada

Kim
Jones

CHIC
IS
BACK

The Satisfaction Issue
The Greatest, October

Editor-in-Chief: **Matteo Greco**
Photography: **Hördur Ingason**
Styling: **Isabelle Thiry**
Hair: **Lasse Pedersen**
Makeup: **Kristina Kullenberg**
Production: **Lomo Management**
Model: **Louis Wood/Nisch
Management**

> "The trend nowadays is in androgynous fashion. *The Greatest* projects this trend, creating the perfect combination of masculinity and femininity in its man."
>
> *Matteo Greco*

A cover in black and white, a mixture between documentary and street style photography. On the right edge of the picture a woman runs into the frame, focusing on her cell phone. In the middle of the image, we see a skater. Is it a boy, a girl, or does it matter?

Louis Wood, the model, is listed with Nisch Management, a Stockholm agency that describes itself as "representing a wider range of beauty, where each model's uniqueness is highlighted, not disguised. We look for strong and striking features... and that 'special something'." All over the planet, unconventional modeling agencies are popping up, looking for unique, unusual, interesting faces. As the modern world challenges Eurocentric and size-specific beauty ideals, the modeling industry is also becoming more inclusive. For decades, the fashion system favored a rigid definition of "model" that was synonymous with "tall, thin and white." The new generation of models authentically represents the diversity we encounter in everyday life – and employing them certainly gives the employer more credibility.

Thus, Louis Wood appears on the cover of a men's magazine, or shall we say, a new generation of men's magazines? *The Greatest* is an independent bi-annual fashion magazine produced entirely in Italy. It was founded in Milan in 2012 by Matteo Greco with the aim of documenting the intriguing and ever-evolving history of contemporary men's fashion. He offers his take on things: "The macho man era has passed definitely. The trend nowadays is in androgynous fashion. *The Greatest* projects this trend creating the perfect combination of masculinity and femininity in its man."

The cover was shot by Hördur Ingason, an Icelandic photographer. Based in Copenhagen, Ingason captures and depicts youth culture with a gentle touch and celebrates a generation that hasn't let the pandemic get them down. "I think there is something so unique with young people," Ingason commented. "The awkwardness, the style, their approach to life, where everything is possible, and they have very little to worry about."

The skateboard also plays a leading role here. Indeed, the pandemic has given the sport another push. It's a bit like surfing on the street – it makes you feel light. It's this feeling of freedom that hardly any other sport gives. And we are longing for freedom so much these days.

THE GREATEST

ISSUE 20 - FALL/WINTER 2021/22

UK 14£ / USA 25$ / AU-DE-FR 17€ / BE-ESNT-IT-PorT 20nl 15C

THE SATISFACTION ISSUE

The Art Issue
Vogue Ukraine, July/August

Editor-in-Chief: **Philip Vlasov**
Photography: **Petra Collins**
Stylist: **Ron Hartleben**
Makeup: **Kali Kennedy/Forward Artists**
Set Design: **Nicholas des Jardins/
Streeters**
Photography Assistants: **Steve Yang,
Moni Haworth**
Stylisting Assistant: **Hayley Francise**
Makeup Assistant: **Sasha Glasser**
Set Design Assistant: **Gautam Sahi**
Casting: **Max Maerzinger**
Production: **Serie Yoon/Night Water
Creative**
Production Assistants: **Jonathan
Smalls, Anija Jalac**
Model: **Tess McMillan/IMG**

> ## "It's not my job to be the gatekeeper of how people interpret it, but it is my job to create imagery that is morally true, or safe, to me."
> *Petra Collins*

This is the cover of the 2021 "Art Edition" of Ukrainian *Vogue*. The editorial tradition of publishing exclusive art projects at the end of the summer began in 2014, when the first art edition of *Vogue* Ukraine appeared with Marina Abramović, one of the leading figures of contemporary art, on the cover. Since then, nine more issues have been created with conceptual projects by artists such as Vanessa Beecroft, Olympia Scarry, Nan Goldin, Coco Capitán and Paul Mpagi Sepuya.

Petra Collins was commissioned as photographer here. The Toronto-born, New York-based artist, photography director, model and actor rose to prominence in the early 2010s. Her photographs are characterized by a feminine, dreamlike atmosphere, marked by the female gaze. She is at the forefront of a new wave of millennial feminism – also called New Wave Feminism – capturing the awkward beauty of early womanhood with her dreamy, pastel photographs. Her work seamlessly weaves together the worlds of art, fashion, film and music.

For this cover, she photographed model Tess MacMillan, who reminds us of a Renaissance beauty with her long, curly red mane, subtle freckles on her snow-white skin and ultra-feminine figure. The Texan model was discovered on Instagram. She has been the face of Italian and British *Vogue* and *i-D* magazine and is booked by Dolce & Gabbana and Marc Jacobs for fashion shows and campaigns. Unlike many of her colleagues, she doesn't need to squeeze or starve herself into a size 34 (and less) for this.

In fact, people in the fashion industry still shy away from speaking directly about body size. They'd rather wax on about inclusivity, about diverse forms of beauty. Even though the world of fashion magazines has become much more diverse in recent years, body diversity and curvy models are still relatively rare in 2021. The ratio has yet to be fully reflective of reality.

The cover of Ukrainian *Vogue* stands for a new feminism – beyond the constrictions of dress sizes.

VOGUE

UA

№7-8 (69)
Июль - август
2021

TESS
MCMILLAN
BY PETRA
COLLINS

THE
ART
ISSUE

CA
PAI
GN

DIOR
Fall 2021

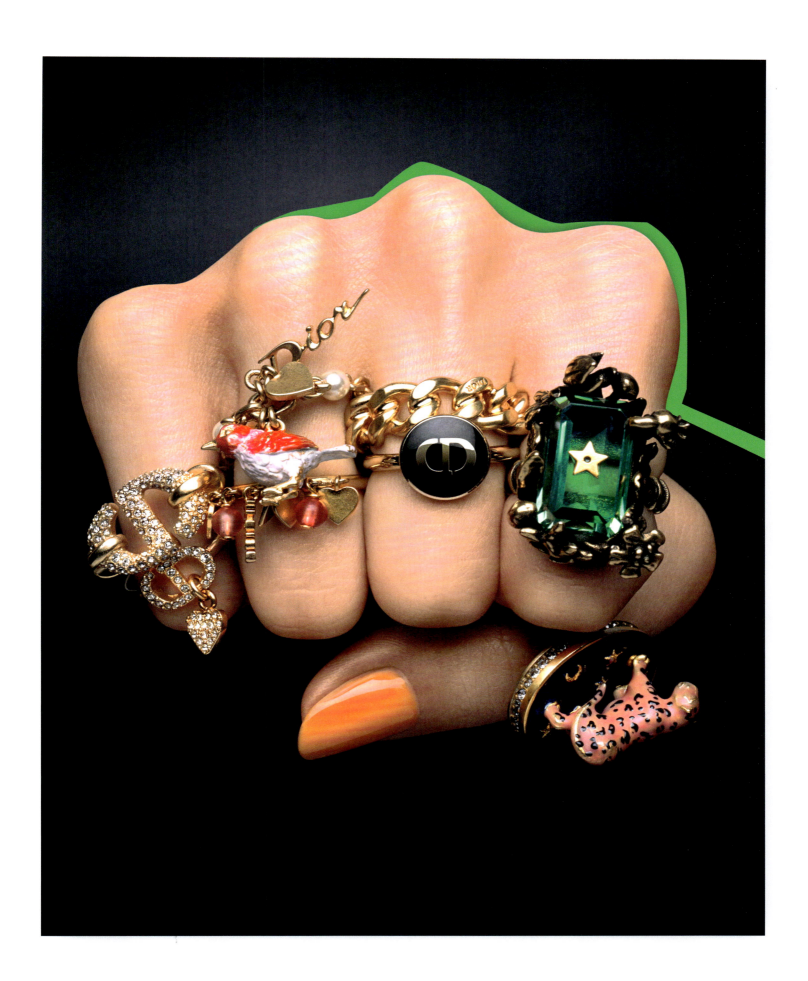

Fall 2021
Dior, Fall 2021

Designer: **Maria Grazia Chiuri**
Photography: **Brigitte Niedermair**
Styling: **Isabelle Kountoure, Lilly Marthe Ebener**
Artist: **Maripol**
Hair: **Olivier Schawalder**
Makeup: **Peter Philips**
Set Design: **Lilly Marthe Ebener**
Casting: **Michelle Lee**
Models: **Steinberg, Sculy Mejia, Kayako Higuchi, Jits Bootsma**

Acid colors and metallic shine merge to create a collection that is bursting with energy. The ultra-colorful campaign reflects a new self-confidence that conveys the vitality and optimism of Pop into the now-future.

It was the heritage of disco fashion that inspired Maria Grazia Chiuri when designing Dior's pre-Fall 2021 collection, and specifically that of Elio Fiorucci, whose aesthetic legacy has left us with a fashion that still has a strong, electrifying appeal. Neon colors, metallic leather and gaudy prints are all a part of the new Dior look. The campaign for the collection, shot by the Italian photographer Brigitte Niedermair, is as powerful and pop as the clothes themselves.

And as for those iconic Dior handbags: it's not so much a lady's hand as it is the powerful fist that is employed to create a feeling of tongue-in-cheek power dressing, chunky adornment galore. The materials are transparent and with shimmering effects, giving the collection a retro and futuristic feel at the same time. Chiuri also sites Mizza Bricard, a muse and loyal collaborator of Monsieur Dior, in the use of her emblematic leopard print reinterpreted here in bright colors. The CD logo is ever present, of course, from subtle to eye-catching ways. The collection looks back at fashion's past while hustling towards the future – hopefully as bold and bright as the pieces presented here.

Chiuri brought in "gatekeeper of '80s club culture" Maripol to collaborate on the campaign. Maripol overlaid a recognizably Warhol silhouette with brightly colored outlines over Neidermair's classic but dynamic portraits.

The campaign is a powerful statement of Maria Grazia Chiuri's continuing use of fashion design to empower women.

"There were no other women in fashion photography in Italy. I was the only one, so there was no cultural reference for me... I had to believe and trust in myself."

Brigitte Niedermair

Stefania M. D'Alessandro/Getty images

Isabelle Kountoure

The German-Greek fashion editor and stylist Isabelle Kountoure, who lives in London, collected issues of American and French *Vogue* as a child. After stints at *Quest* and *Pop*, she spent seven years as Fashion Director for *Wallpaper** magazine. In February 2020, she was appointed style director of the *Financial Times'* *How to Spend It* magazine. Following the motto "less is more," Isabelle looks at fashion in terms of identity and self-expression rather than trends. At *Wallpaper** she started collaborating with photographer Brigitte Niedermair to create their own visual approach to fashion. This got the attention of Dior's Creative Director Maria Grazia Chiuri who has commissioned them to shoot the company's campaigns since Fall/Winter 2019. As well as for Dior, she also works as a stylist for Comme des Garçons, Emporio Armani, Louis Vuitton and Paul Smith. Although she is reluctant to stand in front of the lens, Kountoure's own minimalist, chic look has attracted the attention of street style photographers.

Brigitte Niedermair

Italian-born Brigitte Niedermair has been making photographic works for more than twenty years. She began at an early age, leaving her photography studies to move to Milan and then Miami. During this time, she traveled to New York and Los Angeles to work as a casting director in the film and advertising industries before assisting directors on larger shoots. She met models and actresses on the casting calls and began photographing them in monochrome portraits. Since the 1990s, her projects have focused on the depiction of the female body and the impact of identity. She has been published in magazines such as the *CR Fashion Book*, *Harper's Bazaar* U.S., *Wallpaper**, *W* and *Vogue* Italia. She works for Comme des Garçons and Max Mara, in addition to Dior.

Anonymity
Of The Lining
MAISON
MARGIELA
Spring/Summer
2021

Anonymity Of The Lining
Maison Margiela, Spring/Summer 2021

Design: **John Galliano**
Photography: **Arcin Sagdic**
Casting: **Kyra Sophie**
Production: **Michele Filomeno Agency**
Model: **Pricela Januario/Ethos**

Arcin Sagdic

Arcin Sagdic is a German-born visual artist and director. His work is based on scientific approaches that rely on quantum physics and theories of gravity. Unable to afford the otherwise prohibitively expensive scanning, the self-taught photographer digitized film his own way, manipulating the negatives and even building his own scanner. "I always imagined controlling the chemical phase of the photographic process," he explains. "Building my own scanner was basically the next step of it." He has collaborated with Comme des Garçons Parfums and Burberry. His work has been published in British *GQ Style*, *i-D*, *Dazed*, *10 Men*, *Office*, *The Guardian*, *Numéro Homme* and *V Man*. His latest exhibition project, Asphyxia, shown at La Base de la Marina in Valencia, Spain, in summer 2019, concerned the long-term effects of over a century of industrial plastic production.

Last year was a significant year for fashion and the way it was forced into shifting its presence into the digital realm. For the Spring/Summer 2021 collections, many designers made forays into the realm of video and film. By Fall/Winter 2021 though, most designers had returned to the (analogue) catwalk.

The house of Maison Margiela, however, stayed true to experimental fashion film, with a Nick Knight-directed spectacle called Co-Ed. Over the course of 45 minutes, the genre shifts between documentary segments in which creative director John Galliano reflects on the season's central inspiration, the tango, and models dancing in the romantically sombre collection. To celebrate the Co-Ed collection in-store, two fascinating young contemporary artists were commissioned: Arcin Sagdic and Ezra Miller.

In the campaign pictured here, we see Arcin Sagdic's surreal photographs. Mystical, alienated models float in space. Sagdic himself refers to the "anatomical elegance" of Maison Margiela. Of his own work he says: "I have been alienating form and humanity over the last seven years. Collaborating with Maison Margiela under the title *Anonymity Of The Lining* for the SS21 Co-Ed collection just felt very natural and was a continuation of that vision."

Exploring the limits of the possible in the photographic medium, he uses the distortion of various tactile devices to manipulate negatives, simulating atmospheric differences and creating a sort of parallel aesthetics with chemicals and ink dyes. In the works he created for Margiela's key pieces, Sagdic's aim was to convey the transience of forms and a sense of otherworldliness, a warping of time and matter. He places the models in an environment where the human perception of color and momentum intersects with reality, overriding the laws of physics. What is existing and nonexisting materiality?

"From the first moment I saw the collection, I immediately felt the artistry and precision of John Galliano; from this excitement and inspiration, the direction of our shoot was naturally set," says Sagdic. He performed all the image manipulations on a purely chemical basis and without the use of Photoshop. The resulting campaign is super minimal. Maison Margiela left his work completely intact and only added the house logo to the video.

"I was always interested in the image behind the image."
Arcin Sagdic

*Ultimate
Midnight Angels*
THEBE MAGUGU
Fall/Winter 2021

Ultimate Midnight Angels
Thebe Magugu, Fall/Winter 2021

Design: **Thebe Magugu**
Photography: **Kristin Lee Moolman**
Art Direction: **Chloe Andrea**
Styling: **Noentla Khumalo**
Hair & Makeup: **Annice Roux**
Special Effects Makeup: **Jurine Erwee**
Production: **Jodie Ennik/Lampost Productions**
Casting: **Melissa Voges**
Models: **Sio, Phumla, Amy Zama, Ponahalo Mojapelo, Tamara Moeng, Vanessa Mojapelo, Tracy Mokgopo, Tumi Ntsewa, Siphelele Veti, Beatrice Asi, Kuwornu Siso, Mkhabela Junior Malebese, Prince Ubamara**

Before we talk about this campaign, we need to talk about the designer: Thebe Magugu. He comes from South Africa and was born a year before the end of apartheid. His vision is to retell the African experience outside the structures of colonization, to restore pride in local craftsmanship and to use images and motifs connected to ancestral existence. His collections are a kind of social commentary on cultural history and are influenced by spirituality and the strong women of South Africa's past. "So many African countries have past and present realities that have been stifled by their respective colonizers," the designer says. "Let's retell and rewrite our own story."

In recent years, Thebe Magugu noticed a change amongst his friends. Driven by a connection to their ancestors, they began to explore traditional healing methods. That same African spirituality served as the starting point for this collection and also for the campaign. Stylist Noentla Khumalo's background adds authenticity to the collection: She is a traditional healer. For the main print of the collection, Noentla threw objects she uses for divination – goat bones, an old police whistle, a pencil sharpener, shells and red dice – onto a mat that Thebe Magugu photographed, abstracted and printed onto the main styles.

The film produced for the collection, titled *Banyoloyi a Bosigo* (Ultimate Midnight Angels), was shot by director and photographer Kristin-Lee Moolman. It explores the idea of spirituality through the story of a love affair between two members of rival tribes, with an all-female cast. "I like the idea of creating heroes and mythologies around South African women of all race and of all sexualities – an intersectional view of Africa," says Kristin-Lee of the film. "In the same way the westerns romanticized and reclaimed that period of American history, we too must form our own narratives and realities outside of 'perpetual victimhood'."

"I'm not making work that's going to change our political system or contest anything. It's more a celebration of people and a utopian approach to the future."

Kristin-Lee Moolman

Aart Verrips

Thebe Magugu

Thebe Magugu grew up in the early 1980s in the small South African town of Ipopeng, a township on the outskirts of Kimberley, a mining town in central South Africa. He moved to Johannesburg to study fashion design, fashion photography and fashion media at LISOF. After winning the best graduate collection award with his collection, he interned and worked for a number of designers, fashion institutes and retailers. In 2016, he founded his eponymous label Thebe Magugu. In 2019, he won the International Fashion Showcase at London Fashion Week. That same year, he became the first African designer to receive the LVMH Prize. All this allowed him to present his collection at Paris Fashion Week last year and exhibit his designs at the Costume Institute of the Metropolitan Museum of Art in New York. At the same time, Thebe Magugu founded Faculty Press, a fashion magazine, in 2019. The inaugural publication features more than 150 pages of powerful editorials shot across South Africa as well as texts featuring local artists and activists.

Kristin-Lee Moolman

Kristin-Lee Moolman is a South African-born photographer and filmmaker. She grew up during the political transition between apartheid South Africa and the new South Africa under Nelson Mandela. Her work captures the idea of a "new Africa." She explores the changing social and political landscape of Africa through portraiture and foregrounds Africa's creativity and beauty. In doing so, she counters negative stereotypes about her home country. "I felt so much guilt by association of what my people did to other people," she said. "For a long time, I wanted to get away from being Afrikaans, being White, being South African." Themes of sexuality and segregation in her work play a large role without being overtly political. In 2020, she won the Rudin Prize for Emerging Photographers and has worked with big names like Rihanna in a shoot for the *New York Times Style Magazine* and with fashion houses such as Dior and Burberry. Other clients include *Vogue* UK, *Dazed*, *Double*, *i-D* and *M Le Monde*.
Recent exhibitions (in collaboration with stylist IB Kamara) include "Items: Is Fashion Modern?" at MoMA, NY, and "Being There: South Africa, A Contemporary Art Scene" at the Fondation Louis Vuitton, Paris.

Jersey Campaign
BALENCIAGA
Fall/Winter 2021

HI

MY NAME IS

IF I AM LOST
TAKE ME TO THE
BALENCIAGA
STORE

BALENCIAGA

Jersey Campaign
Balenciaga, Fall/Winter 2021

Photography: **Daniel Roché/Shotview Artists Management**
Visual Direction: **Guillaume Harrison**
Visual Project Management:
Roxanne Leger
Visual Project Coordination: **Elena Tetu**
Creative Research & Talent
Coordination: **Leonie Miller-Aichholz**
Styling: **Laëtitia Gimenez Adam**
Hair: **Dushan Petrovich**
Makeup: **Ana Buvinic**
Set Design: **Sandro De Mauro**
Photography Assistants: **Lennart Sydney Kofi, Belen Rovegno, Flavia Renz**
Digital Operation: **Michael Petersohn**
Hair Assistant: **Kosuke Ikeuchi**
Makeup Assistant: **Gianluca Venerdini**
Production: **Vera Massias/Farago Projects, Lydia Wagner/Made In Germany Production**
Models: **Alexandra/Deebeephunky, Christine/Das Deck, Erwin, Nayme/Tiad**

BALENCIA

"I hope we will live at one
point in the near future:
somewhat 'unpolished,'
exciting, free and spiritual."
Demna Gvasalia

Models in an empty studio in street wear: t-shirts, sweatshirts, jeans. Photographed by Daniel Roché, perhaps the most striking styling feature about the Balenciaga "Jersey" campaign is that we never see their eyes. Completely absorbed in their own virtual worlds, the models seem unaware of the fact that they are being photographed in the real world. They are wearing virtual reality headsets; some of them are holding controllers and standing in action-ready positions, while others are in more of an observational pose. And while their mindset has been catapulted into the virtual world, their physical bodies remain mundanely rooted in a photo studio, i.e., the very real world of fashion.

But what is the real world? What has become of it? It says a lot that we have an abbreviation for that now: irl (in real life). There once was a time when that "real" realm needed no distinction.

In recent months, we have become alarmingly accustomed to digital presentations and video calls. Meetings are no longer fleshy affairs over café or conference tables, but take place via email confirmations, links and copy-paste codes. Zoom is the new norm.

So what does the near-future hold, how will we meet next year? Will conferences take place with VR goggles that beam us into the simulation of 3D-presence? As the world adapts to the new digital reality during lockdowns, it becomes increasingly difficult to separate reality from fiction. In many ways, lockdown feels surreal, sci-fi. We've been beamed into an alternate dimension without having had any preparation for what was about to hit us.

Creative Director Demna Gvasalia gets to the core of this existential crisis in his Fall/Winter 2021 Balenciaga collection, turning virtual reality into a vision.

In December 2020, Balenciaga sent out invites to the Fall/Winter 2021 fashion show. An original video game titled "Afterworld: The Age of Tomorrow" was made available to the public through the brand's website (and is still on YouTube). An Oculus headset, with which it was possible to see a complete catwalk show of a collection, was sent to about 30 press representatives – and what did they see? A dystopian future of 3D-rendered characters in black suits in a drab, grey room waiting for their turn to put on virtual reality goggles that, when on, make life all-the brighter.

This print campaign is but one piece of a bigger puzzle that Balenciaga has presented as a greater whole (with video campaigns being given more precedence). With these campaigns, questions are raised about our future and our relationships with others – and how these are being reshaped by technology. Steeped in escapism and existentialism, Gvasalia's dystopia is also drenched in hope.

Daniel Roché

Daniel Roché discovered his passion for photography during an internship at an advertising agency. As a student, he was spotted by a renowned photo agency and signed a contract at the age of 25. Roché quickly developed his very own signature and highly stylized images. He is known for his expressive and emotive work and his ability to capture youthfulness. In recent years, Roché has expanded his portfolio to moving images. He works for various clients such as Balenciaga, Martin Grant, Max Mara, Chanel, Adidas, Diesel, Mercedes-Benz and for selected magazines such as *Numéro* Berlin, *Numéro* Paris, *Odda*, *Dazed*, *GQ* Germany, *GQ* Italy, German *Elle*, *Marie Claire* NL and *Tush* magazine.

*Invitation
To Travel*
CHANEL
Cruise 2021/22

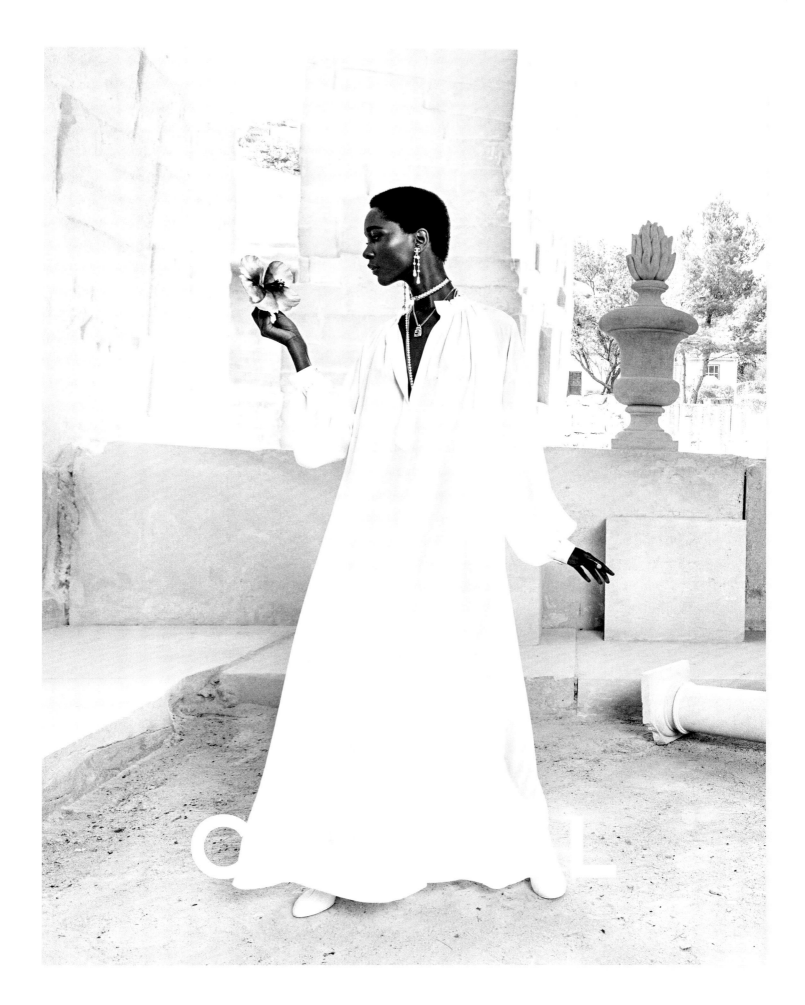

Invitation To Travel
Chanel, Cruise 2021/22, campaign

Creative Direction: **Virginie Viard**
Photography: **Inez & Vinoodh**
Models: **Anna Ewers, Lola Nicon, Louise de Chevigny, Mahany Pery**

Chanel, Cruise 2021/22, press kit pictures

Creative Direction: **Virginie Viard**
Photography: **Inez & Vinoodh**
Model: **Lola Nicon**

The photographer duo Inez van Lamsweerde and Vinoodh Matadin shot the new Cruise Collection by Chanel in the cool light of the South of France. The models were placed in a kind of Freudian *fort-da* situation to create a sense of space which is very much in the yo-yo tone of the day, so close, so far-away.

The inspiration for the collection also came from Provence. Like her predecessor Karl Lagerfeld, the new Creative Director of Chanel Virginie Viard draws on the house's deep histoire. Coco Chanel was a friend of the luminary artist, poet, filmmaker Jean Cocteau, and it was Cocteau that Viard had in mind when she designed the Cruise 2021/22 collection: "I love [Cocteau's] film *Testament of Orpheus*. In particular, this magnificent scene: a man with a black horse's head descends into the Carrières de Lumières, his silhouette cut out against the very white walls".... It was here in these "Quarries of Light," a striking limestone cave-like setting, that the fashion show was staged. She continues: "Echoing the extreme modernity of Cocteau's film, I wanted something quite rock. Lots of fringe, leather, beads and sequins, t-shirts bearing the face of the model Lola Nicon like a rock star, worn with tweed suits trimmed with wide braids and pointed silver Mary-Janes. A look that recalls as much the modernity of the sixties as that of punk..."

Gabrielle "Coco" Chanel and Jean Cocteau were close friends; he created some evocative portraits of her and illustrations of her dresses, and she, in turn, did costumes for some of his plays. They spent many hours in Chanel's apartment at 31 rue Cambon in Paris. The apartment was listed by the Ministry of Culture as a historical monument in 2013, in recognition of its national significance, so it only seemed natural that Viard would choose it as the setting for the dramatic black-and-white spread, again the work of Inez & Vinoodh, giving us a brief but intimate glimpse into Chanel's rich past and present.

Model Lola Nicon features in both campaigns of the same collection. In the black-and-white spread, Nicon is styled into the role of punky granddaughter of Chanel. Inez & Vinoodh again play with the notion of emotional expansion by using a fisheye lens that widens the sense of space within the lush interiors.

Inez & Vinoodh
The award-winning photography duo met while studying fashion in their hometown of Amsterdam. As both life and work partners, their breakthrough came in 1994 when the British magazine *The Face* took notice of their work. The two used digital special effects in dramatic ways when the technology was still new, expensive – and rare. *The Face* published a series called "For Your Pleasure," in which the duo digitally overlaid their own candy-colored, retro-futuristic photographs of models onto backgrounds they had acquired from an image database. Today, Inez & Vinoodh work for American, Italian, Japanese, Chinese and French *Vogue*, as well as *W, Vanity Fair, Harper's Bazaar, L'Uomo Vogue, Purple Fashion, Interview, self service, Pop, i-D, Fantastic Man* and many more. In over 35 years of working together, they have photographed campaigns for Yves Saint Laurent, Isabel Marant, Miu Miu, Gucci, Chloé, Givenchy, Calvin Klein, Balenciaga, Chanel, Stella McCartney, Loewe, Louis Vuitton and Helmut Lang. They are married, have a son and live in New York.

Lola Nicon

The French model Lola Nicon grew up in Toulouse, but was first scouted while attending a festival in Belgium. "I was queuing up to get some water and someone asked me if I was a model. I said, 'Not yet!'" Her skyrocketing career took off in 2019. Thus far she has been on the cover of *Vogue* Russia, *M le Monde*, *V Magazine*, *Pop*, *self service* and *AnOther*; and in the editorials of *Elle* Russia, *Glamour* Spain, *Vogue* UK and France, *WSJ*, *The Gentlewoman* and more. She has walked shows for Louis Vuitton, Chanel Haute Couture, Etro, Alberta Ferretti, Roberto Cavalli. Next to Chanel, she has been the face of a Louis Vuitton and a Chloé campaign.

"In fashion you are talking in codes and constructing a character based on your own memories."

Inez van Lamsweerde

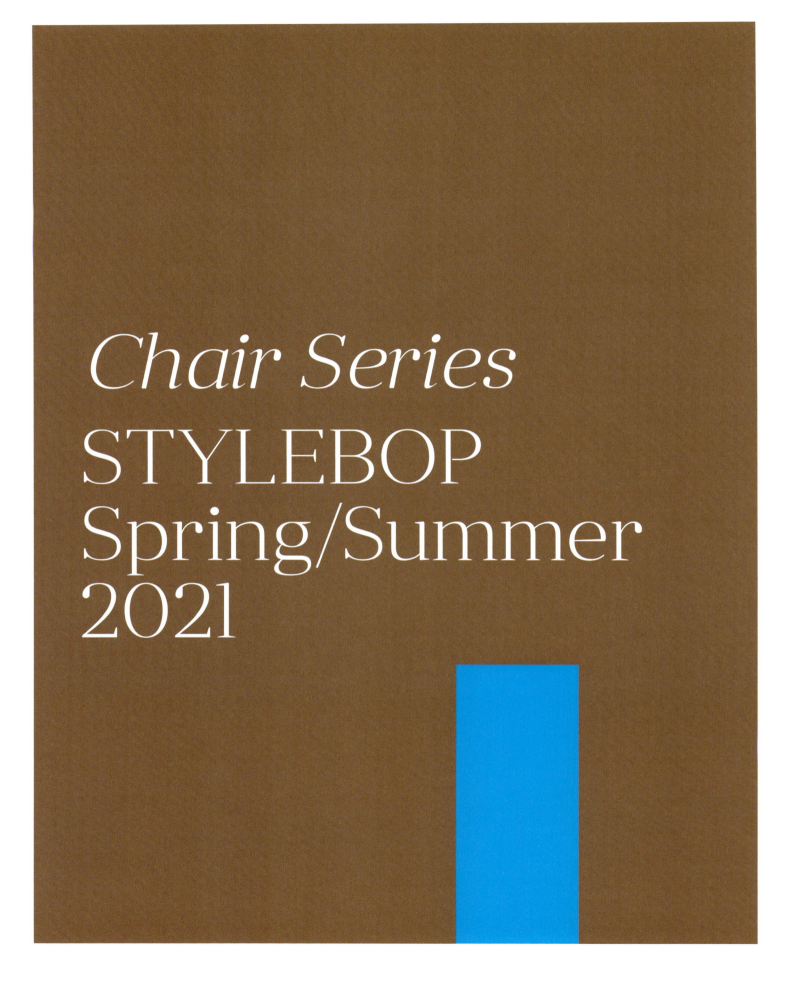

Chair Series
STYLEBOP
Spring/Summer
2021

Chair Series
Stylebop, Spring/Summer 2021

Photography: **Andreas Ortner/
Schierke Artists**
Styling & Art Direction: **Elke Dostal/
Nina Klein Artist Management**
Hair & Makeup: **Denise Grundmann,
Anna Neugebauer**
Models: **Edge, Jade Muller, Mariana
Osantana**
Location: **Spreegraphenstudio Berlin**

Modern chairs stacked in an empty studio. Both chaos and order are on equal footing here. Photographer Andreas Ortner is known for his ingenuity, and for lending his images emotional depth. He finds his inspiration in everyday life and even, as in these pictures: in chairs.

Are these chairs a symbol for our time or how are we meant to read them? Potentially, they indicate the greater question: Where is my place in life? And if so, is the answer pictured here: on a wobbly throne? Enticingly precarious with adventure at every turn? Or all sorted out? How do we choose to live – upright or continually adapting to the circumstances? The question is then: How much are we meant to tolerate the painful bends?

Another note: All the chairs are without upholstery. Toughen up, they suggest. Life is not about ornament but functionality. But is life really meant to be that hard? Possibly we're being shown a different story altogether. After all, the chairs are piled up like abstract art. And in a pile, a chair is basically rendered useless.

Inevitably, the images remind us of the installation of chairs by Ai Weiwei at the Venice Biennale 2013 of some 886 wooden stools installed (seemingly chaotically) as a rhizomatic structure, and as a metaphor for the loss of the individual in relation to an excessive and speed-addicted world. Or the impressive installation by Doris Salcedo at the 8th International Istanbul Biennale, where she stacked 1,550 chairs in a vacant space between two houses. The chairs stood as memorials to the history of migration and displacement in the city of Istanbul. In both installations, the chair stands as a proxy for the human being in a wobbly world – in the mega-cities, in a transforming society. Stylist Elke Dostal rooted the models in chunky boots, suggesting a grounding and steadfastness in those who seek answers to these questions.

Oliver Beckmann

"I'm not afraid of failing; it is part of the creative process."
Andreas Ortner

Elke Dostal

After several years as an editor and deputy fashion director for fashion magazines such as *InStyle* Germany, Elke now works as a freelance stylist for international magazines. "I love the act of creation, when the model is not only beautiful and perfectly dressed but expresses something more, a modern and authentic feeling, a sense of now. That's when I feel truly touched. That's how I find a part of myself in everything I do." Elke currently lives in Munich and London.
As a stylist she works for *Vogue* Germany, Portugal, Ukraine, *Elle* Romania, Russia, *Glamour* Italy, Turkey, *Highsnobiety*, *Interview*, *GQ* Germany, *Harper's Bazaar* Czech, *Marie Claire* Czech, Hungary, Indonesia, Malaysia, *Numéro* Russia, *Nylon* and *Schön!* Her clients include Birkenstock, Bucherer, Escada, Hermès, Hugo Boss, Mercedes, Michael Kors and Montblanc.

Andreas Ortner

Born and raised in Innsbruck, the Austrian photographer has been in the fashion industry for over twenty years. A former model, he bought his first camera, an analog Pentax, at a flea market in Brooklyn, New York, in 2005. Analog photography continues to shape his approach to image-making even today. It requires craft, knowledge and discipline, qualities that Andreas applies also to his digital work.
Traveling throughout the USA, Europe, Canada and Asia, he trained and honed his skills, working with inspiring photographers such as Steven Klein. Today he lives and works between Munich and Prague.
His clients include Aigner, Baldessarini, Bogner, Chopard, Lacoste, Mytheresa and Wempe. He launched several exhibitions, such as "Un Hommage à la Passion" at W Hotels across Europe and at Art Basel in Miami and Tokyo. His images have been published in international editions of *Vogue*, *Elle*, *Harper's Bazaar*, *L'Officiel* and *Numéro*.

SEIT 1884

© 2022 Callwey GmbH
Klenzestrasse 36
80469 Munich
buch@callwey.de
Tel.: +49 89 8905080-0
www.callwey.de
On Instagram: @callwey

ISBN 978-3-7667-2578-3
1st edition 2022

Bibliographic information of the German
National Library

The German National Library lists this
publication in the German National
Bibliography; detailed bibliographic data are
available on the Internet at http://dnb.d-nb.de.

Project Management: Johanna Böshans

Final Correction: Sonja Illa-Paschen

Production: Dominique Scherzer,
Oliver F. Meier

This book was made in Callwey quality

For the content pages, we have chosen 150
gsm Magno Matt – a wood-free, matt-coated
paper with a smooth, non-reflective surface,
which gives the content an elegant and
high-quality character. The hardcover is
printed with Pantone Process Cyan color and
additionally the book was provided with a deep
black color cut. This book is printed and bound
in Germany by Optimal Media GmbH in Röbel/
Müritz.

We hope you enjoy this book.

Editor: Julia Zirpel has more than 20 years'
experience as a fashion editor and director of
magazines such as Interview Germany, *Myself* and
Cosmopolitan Germany. Based in Munich, Julia is the
co-founder of the sustainable fashion e-commerce
platform thewearness.com and has established
herself as a freelance sustainability, creative and
content consultant.

Art Director: Fiona Hayes is a designer, art director
and university lecturer with three decades of
international experience in publishing, art, luxury retail
and fashion. A former art director of ten magazines,
including Russian *Vogue* and *GQ* India, she has been
involved in the launch of 14 titles for Condé Nast. She is
currently based in London.

Picture Editor: Katja Sonnewend is a photographer
and photo editor based in Berlin. She holds a Master of
Arts in photography and has been published in *Zeit
Magazin*, *Süddeutsche Zeitung* and *Stern*. Katja has
also worked as a freelance photo editor for the German
editions of *Vanity Fair*, *Vogue* and *GQ* as well as *Rolling
Stone* and has contributed to advertising campaigns
for Mercedes-Benz, Bucherer and Silhouette.

Contributing Editor: April von Stauffenberg is a
writer, stylist and art consultant based in Berlin. She is
also the Executive Editor of the annual *Zeit Magazin
International*. In 2018, she founded the slow-fashion
label After March – and was immediately picked by
Vogue Italia's Vogue Talents "as one to watch."

**The Editors would like to thank the following
for their help and support in putting together
*The Fashion Yearbook***

Sonja Spies-Orlowski, Melissa Scragg, Paula Bento, Lucyna
Szymanska, Julian Niznik, Chris Neal, Madeleine
Abeltshauser, Ntombi Khambule, Maximiliane
Schmalenbach, Felix Frith, Constantin Katsachnias, Flora
Clérico, Lili Menadiyeva, Arnaud Daïan, Jo Evendon, Mischa
Notcutt, Xavier Girodon, Phuong Lan Ho, Dana Kien,
Stefanie Breslin, Tim Zimmermann, Manuela Hainz, Goran
Macura, Christopher Michael, Rachid Boumali, Nicolas
Larriere, Bradley Davis, Peggy Pannocchia, Daniela Vogt,
Cristina Palumbo, Danil Belobraga, Kozva Rigaud, Elizabeth
Carpenter, Jacob Epstein, Sara Chan, Effi Günther, Samira
Fricke, Ralf Zimmermann, Elena Serova, Chris Lucas,
Erwann Le Hen